EXPLORING FLOWERS IN WATERCOLOUR: TECHNIQUES AND IMAGES

SIRIOL SHERLOCK

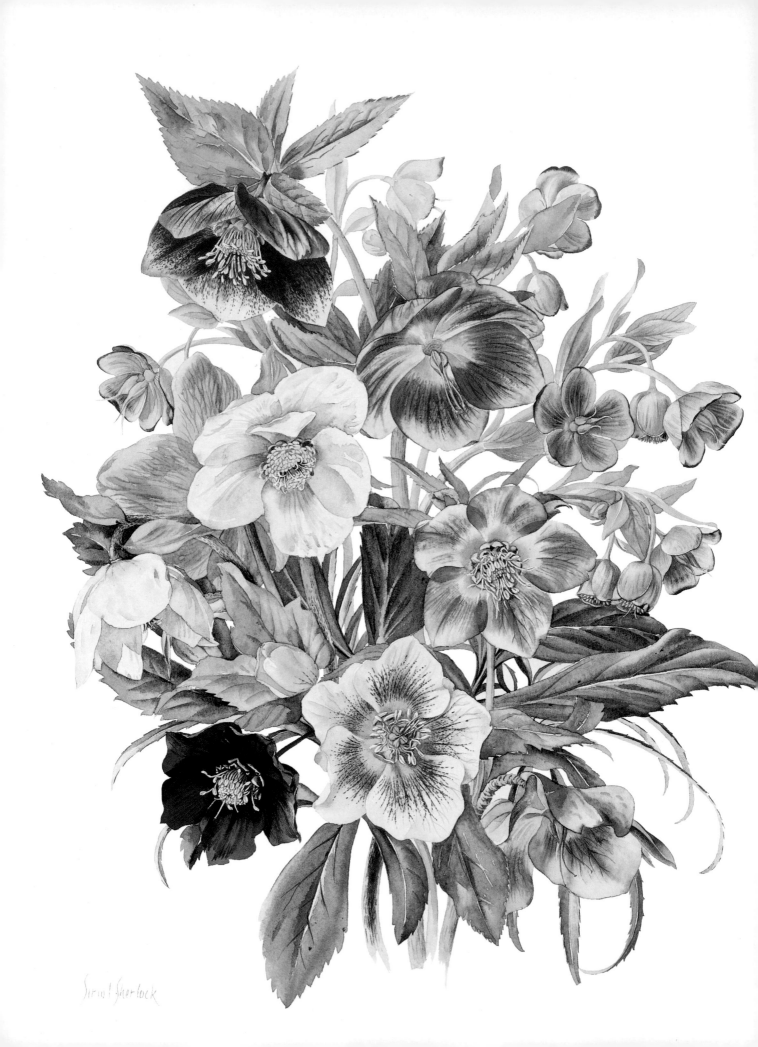

EXPLORING FLOWERS
IN WATERCOLOUR:
TECHNIQUES AND IMAGES

SIRIOL SHERLOCK

B.T. BATSFORD LTD, LONDON

DEDICATION

To Steve, Alexandra and Sophie

ACKNOWLEDGEMENTS

I would like to thank my husband Steve for his patience while I monopolised his computer during the writing of this book and my children, who have grown accustomed to late meals and late collection! Also my parents, Joan and Sandy Cattanach, for their support, advice and encouragement, not only while preparing the book, but throughout my career. Thanks to Peter Collett and fellow artists for their advice on cut flower care. Most of all I would like to thank all my enthusiastic patrons who have bought and commissioned paintings over the years and whose wonderful compliments have kept me painting; this book would never have been written without them.

First published in 1998 by
B.T. Batsford Ltd
583 Fulham Road
London SW6 5BY

A catalogue record of this book is available from the British Library.

ISBN 0 7134 8024 6

Printed in Hong Kong by Colorcraft Ltd.

Photographs of the finished paintings by Paul Reeves, Gordon Hammond Photography and Blitz

Designed by DWN Ltd, London

CONTENTS

INTRODUCTION

How long did it take you?

I've heard this question a thousand times! However, I try to avoid giving my answer in minutes, hours or days as I feel it isn't the length of time taken that gives a painting its value, it is the quality of that painting. Of course I could answer 'twenty-six years', as that is the number of years I have been painting and adding to the experience that went into that individual painting! Some of my best paintings were done in a day, perhaps because I was inspired by my subject and I painted freely and spontaneously; others have taken weeks of concentration and tend to be valued more highly by people because they can appreciate the hours of work that went into such detail. The quick, inspirational painting can be just as demanding as the long, detailed one, but the satisfaction comes much sooner. Painting is a very enjoyable occupation, but it is not as light-hearted and relaxing as the non-painter imagines.

Invariably people expect my paintings to have taken a great deal longer than they have. Flower paintings can be effective, dramatic and realistic without becoming an endurance test. A botanical study doesn't have to be tight and rigid, it can be flowing with life and vitality. In essence the flowers should be realistic and alive – this is what I try to achieve when I paint flowers.

Throughout the book I have given the picture size, brush sizes and time taken for each painting. Picture sizes are the approximate sizes of unframed paintings and brush sizes show what can be achieved with different brushes. Times are only approximate, as I lose all track of time when deeply absorbed in a painting.

Also, wherever a finished painting is shown, details on the method of construction and other useful tips are given to help when you paint a similar subject. Any technical terms will be made clear in Painting techniques (see page 28).

This book is about a way of painting which should enable you to paint any flower species, from a huge oriental poppy to a tiny snowdrop, or, for that matter, even a landscape, still-life or portrait. Essentially this is a wet way of painting for the watercolour painter, and not the rather dry, labour-intensive method traditionally used by many botanical artists. I am not going to show you in very great detail how to paint individual flowers, because you will be painting your own flowers, not mine. My directions and examples are here to follow, but you must then progress to painting your own pictures from life.

You can't expect miracles overnight, but I hope you will be extremely happy each time you make a small breakthrough – perhaps achieving a sparkling highlight on a shiny berry, the bright translucent red of a field poppy, making a leaf look shiny or just painting a flower that is recognisable. Do not give up if you don't get instant results, for flower painting is not a soft option, but involves hard work and deep concentration. You must persevere and learn by your mistakes; do not tear them up, however, as one day you may look back at them and be amazed by the improvement you have made. Throughout this book I will give you the benefit of all the tips I have discovered over the years, but remember that the only real way to learn is by experience.

Fig. 1

Intertwined
20 x 14 in (51 x 35 cm), 1 day,
brush sizes 8 and 5

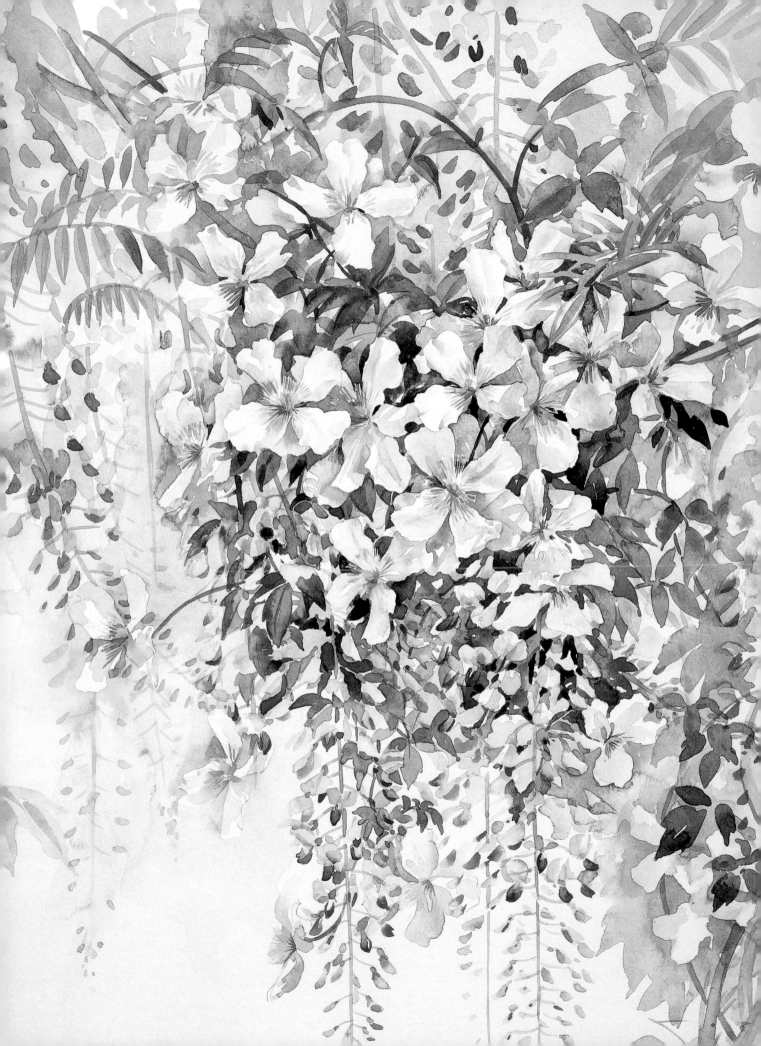

SECRETS OF SUCCESS

The secrets of painting flowers in watercolour successfully, which in fact hold no great mystery, will be unfolded in full in the following chapters. In essence they are as follows:

Working from life

If you don't work directly from life you cannot expect to achieve life-like results. I know I can't. If you try to paint a plant that is unobtainable or out of season you will have to 'make up' the picture from a combination of sketches, pressed specimens, photographs and other artists' illustrations, which will invariably not do you, or the plant, justice. It would not look 'alive'. I know some botanical artists are forced to work in this way, perhaps because it is impossible to obtain a living specimen. I admire their skill enormously, but this way of working would not suit my style of painting.

Good observation is vital: when you have the real plant in front of you it is possible to observe everything, its shape, details, colour and character – is it delicate, thin and papery like a poppy, or strong and upright like a magnolia? Being able to capture its character is perhaps more important than anything else.

Painting quickly is also important when painting from life. Painting cut flowers can be a race against time as the flowers may be opening, moving, wilting and dying in front of your eyes. There are many ways to overcome these problems (see page 25).

Little or no pencil

None of the above will be possible if you spend hours drawing your flowers before you even pick up a paintbrush – the flowers will probably be dead or wilted by then anyway. This book is about using watercolour, so you may as well put those pencils away. If you draw the picture first, the paint will just be used to 'colour in' and you will have lost the wonderful freshness and spontaneity of watercolour. Even if you are inexperienced at drawing, you can learn to create lovely, fresh impressions of flowers that are instantly recognisable. However, I would never underestimate the value of learning to draw, but remember that if you can draw with a pencil, you can draw with paint – it just takes a little more courage. Of course watercolour cannot be rubbed out but it is very flexible while it is wet and it will be used very wet throughout this book.

Large brushes

Choosing the right equipment and materials is absolutely crucial if you are going to have a chance of producing brilliant watercolour paintings (see pages 12–17). Large brushes are the real key to the watercolour technique, forcing you to use the paint and let it flow. They don't have to be enormous, but they must have good water-holding capacity and a fine point. Obviously you wouldn't choose a size 12 brush for a tiny snowdrop painting, but a size 6 with a fine point can do almost anything that can be achieved with a size 1 and it has the advantage that it holds much more paint. *The Little Pouring Pot* shown here was painted mostly with a size 6 brush and details such as the tiny eyes of the forget-me-nots were added with a size 3.

Letting the paint flow

Don't dab at the paper or use tiny brush strokes – let the paint flow. This takes courage if you are used to a size 000 brush and minuscule quantities of paint; but have a go. Always mix pools of your main colours so that you have plenty of paint ready to hand. If you are just starting out, make the most of this wonderful opportunity to begin painting this way before you get bogged down in slow, laborious techniques. As you will see from many of the examples in this book, you can learn to control the paint and achieve the most accurate and realistic studies that would satisfy any botanist and, at the other end of the scale, produce a wonderful quick impression in half an hour.

Using the translucency of watercolour paint

Let the paper show through the watercolour, don't let the paint become muddy, opaque or overworked. This will not be possible if you are not using the right equipment and materials.

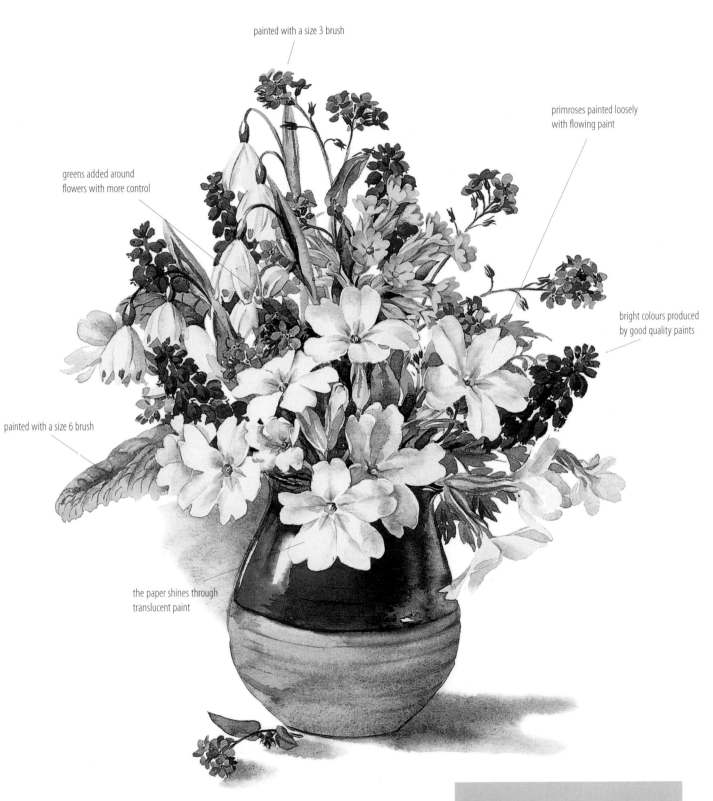

painted with a size 3 brush

primroses painted loosely
with flowing paint

greens added around
flowers with more control

bright colours produced
by good quality paints

painted with a size 6 brush

the paper shines through
translucent paint

Fig. 2

The Little Pouring Pot
11 x 10 in (28 x 25 cm), 1½ days,
brush sizes 6 and 3

Finding inspiration

It really is important to feel enthusiastic about your subject. Something about it has to inspire you – beauty, colour, light, form, size or shape. Even the most ordinary little daisy has something to offer; when you examine it closely, it no longer seems so ordinary and if you can capture it on paper it can look really special. You will find it hard to do justice to a flower that you positively dislike and it may test your endurance to finish the painting.

Morning Light

I came downstairs one morning to find the bright spring sunshine streaming through this vase of flowers on my window sill and the luminosity of the petals inspired me. I knew that the sun would soon move away from that window, so I grabbed paintbox, brushes, water pots and watercolour pad without stopping for breakfast. There was no time to wait for colours to dry and many of them merged together, however it was important to make sure the flower colours were dry before wetting the paper around them and washing in the background. This was because a sharp contrast was needed between the bright flowers and the background behind them.

Colours
Permanent rose, scarlet lake, permanent carmine, Winsor yellow, sap green, French ultramarine, bright red

Method
1 The pink tulips were painted first.
2 Then the shadows on the white flowers were added (using French ultramarine and bright red to make grey). White is the colour of the paper, no white paint was used; see White flowers on page 68.
3 Then the pink blossom was painted.
4 The light and dark green leaves and stems were added, avoiding the chrysanthemums and freesias.
5 A quarter of the background area at a time was wetted and colour was added around the flowers allowing it to flow into the wet area, wet-on-wet (see Backgrounds on page 114).
6 The darker details on the tulips, chrysanthemums, blossom and dark green eucalyptus shoots were painted, wet-on-dry.
7 The vase and shadows on the ducks were added.
8 Then the leaded panes were put in, wet-on-dry.
9 Finally, the background behind the vase and ducks was painted, adding stronger colours wet-on-wet.

Fig. 3

Daisy
Life size, 2 hours, brush size 3

Tip

Because I didn't stretch my paper for *Morning Light* and my paint was very wet, the paper cockled (went bumpy; see Stretching paper on page 24). A watercolour pad sealed around the edges would have prevented this, but as a last resort a good framer would be able to 'dry mount' the painting – this seals the paper to board, thereby flattening it.

Fig. 4

Morning Light
12 x 10 in (30 x 25 cm), 1½ hours, mostly brush size 10

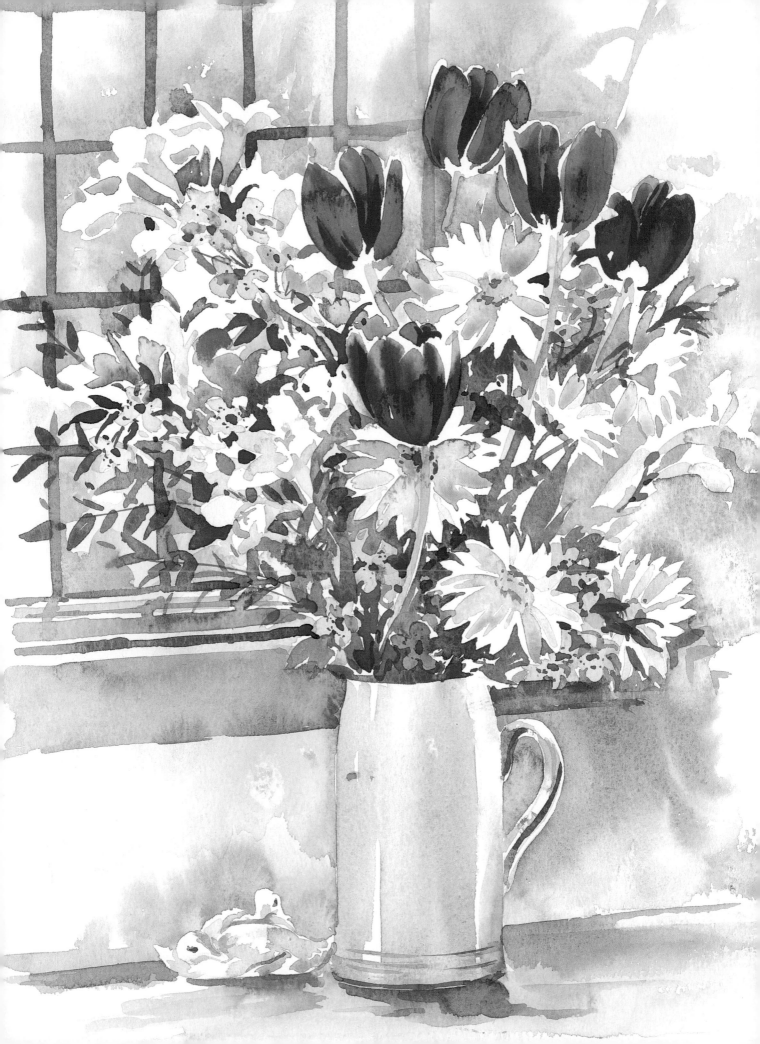

CHAPTER 1

MATERIALS AND EQUIPMENT

Brushes, paints and paper are equally important; if any one of these is
poor quality or unsuitable your results will invariably be disappointing.

Brushes

I used to swear by pure sable brushes and would never
recommend anything else, but more recently I have
been converted to some of the synthetic and sable
mixtures and even some of the pure synthetics. You
really can't beat a good-quality sable, but the larger sizes
are far too expensive for the average artist.

The most important qualities of a brush are:
• a sharp point.
• good water-holding capacity.
• springiness – the brush should spring back into
shape after each stroke.

A variety of sizes between 2 and 14 is useful, but with
just two brushes, say sizes 5 and 10, you should be able
to paint almost anything. You should never need to use
anything smaller than a size 2, and use that only for the
finest details. As smaller brushes hold practically no
paint, you waste valuable time continually 'refuelling'
them. It is a good idea to have two or more brushes in
operation at any time – a different colour on each brush
and one loaded with clear water. This saves time and
paint as you do not have to rinse your brush every time
you change colours.

The brush strokes illustrated below show how each
brush can perform.

Tip

Some synthetic brushes get an annoying kink at their tip
after extensive use; this can be remedied by briefly dipping
the brush in boiling water and immediately re-shaping the
point.

The pictures in this book were painted using a variety
of brushes including the following: Winsor & Newton
series 16 sable, Winsor & Newton series 33 'School of
Art' Sable, Yarka Kolinsky Sable, Pro Arte series 100
synthetic and sable and some unlabelled, cream-
handled, synthetic brushes which perform just like
a sable.

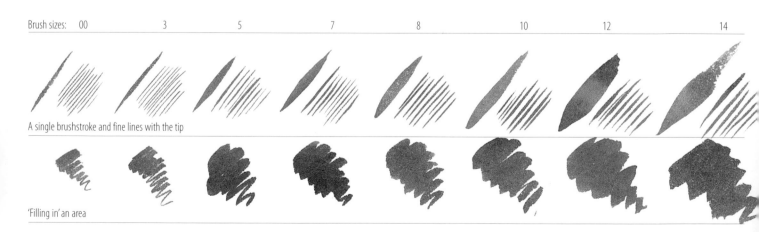

Brush sizes: 00 3 5 7 8 10 12 14

A single brushstroke and fine lines with the tip

'Filling in' an area

Fig. 5

Brushstroke samples. You can see that the larger size
brushes are much more efficient when 'filling in' and
yet they are also capable of producing quite fine lines.

two water pots

art masking fluid

an assortment of brush sizes

ube of white gouache

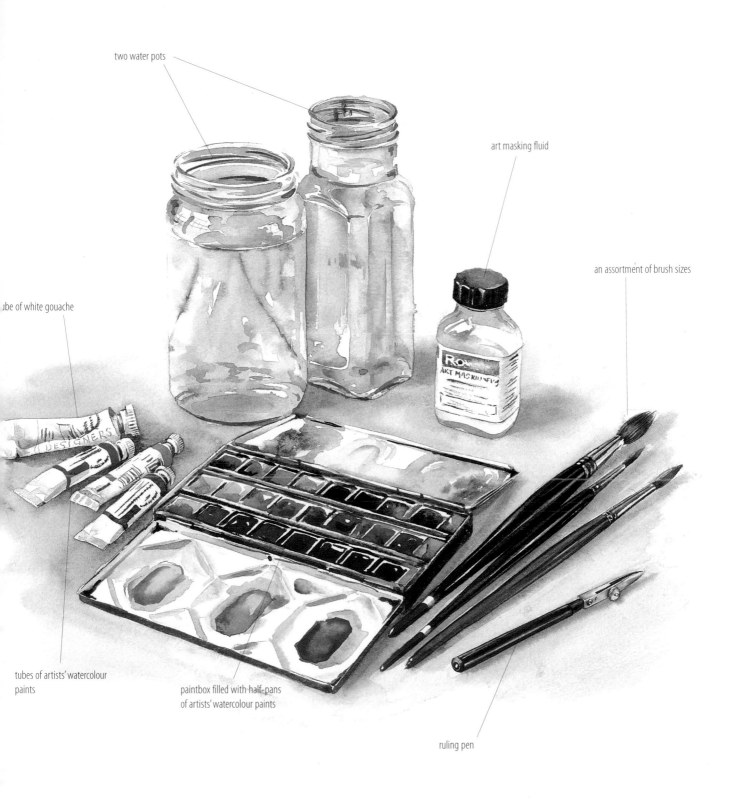

tubes of artists' watercolour
paints

paintbox filled with half-pans
of artists' watercolour paints

ruling pen

Fig. 6

Materials

Paper

The type of paper used can greatly affect a watercolour painting and, if inappropriate, can make a picture look lifeless. I didn't know anything about watercolour papers when I started to paint flowers. My first attempts were on white cartridge paper which I had used for my textile designs. It was great for designs painted with gouache, but made my watercolours look dull. I quickly moved on to a popular brand of watercolour paper but found that it may have been suitable for landscapes, but it was definitely not suitable for flowers. It is important to test out different types of paper before buying in quantity; sample packs containing many different papers are available from some of the larger suppliers.

Watercolour papers come with different surfaces:
- Hot pressed (HP) – very smooth and good for fine, detailed work, but rather a dead, sterile surface.
- NOT (meaning not hot pressed) – has a slight surface texture and is good for most paintings, even quite fine detail. A more lively surface.
- Rough – highly textured and good for landscapes or impressionist, lively flower paintings. Not suitable for detailed work.

Paper also comes in different weights:
- 90 lb (190 gsm) – rather thin; it is fine for a sketchbook if you accept the fact that the sheets will cockle. If you use it for a finished painting, it is essential that you stretch it first (see page 24) and the painting will always be susceptible to cockling if it gets damp. Fine for learning and experimenting, but who knows when one of those experiments might turn out to be a brilliant painting?
- 140 lb (300 gsm) – suitable for most paintings, but if you use a lot of water when painting, as I do, you will need to stretch your paper first.
- 200 lb (425 gsm) – as thick as cardboard; this probably won't need stretching, but it might still cockle if you use a lot of water.

Most watercolour papers still come in imperial sheets measuring 30 x 22 in (76 x 55 cm). It is cheaper to buy sheets and cut them to size, although pads (especially those that are gummed round the edges) are useful in the field.

Brands of paper vary enormously in surface texture, colour and price; the most expensive are not necessarily the best for flower painting. I prefer a NOT surface, although some NOT papers (such as 'The Langton' pads and 'Arches') have a rather dry, rough surface which I don't like for flower painting. Others (such as Winsor & Newton's 'Cotman', which only comes with a NOT surface), have a smoother, undulating surface which allows the paint to flow more easily. 'Bockingford' is very similar to 'Cotman', although I suspect the paint colours do not glow quite as much. Paper colour is very important, so choose a paper which looks clean and bright as it will make your colours glow; those which are too dull and creamy will make your paintings dull.

For most of the paintings in this book I have used Winsor & Newton 'Cotman' 140 lb (300 gsm) which I stretched first.

Paints

For some reason watercolour painting was not encouraged when I was at art school and painting flowers was considered to be old fashioned! So when I started to paint flowers seriously some years later I was really starting from scratch. I began with a box of Students' watercolours and was extremely disappointed with the results, in fact I was close to giving up. In a moment of extravagance I bought myself an expensive metal paintbox and gradually, as I could afford them, I filled the empty spaces with little half-pans of Artists' watercolours. Many years later, I am still using that paintbox and the pans have been refilled many times; perhaps that is why they are so expensive – the manufacturers know they will only sell you one in a lifetime!

Be sure to buy a paintbox with room for expansion, mine was only meant to hold 16 half-pans but I have filled the central section, which is intended for brushes, with another 8 colours. If you already have a box of Students' watercolours, you can gradually replace the pans with better-quality paints (they are usually the same size, but check that they fit before you buy). Your paintbox should also have some decent-sized wells for mixing pools of colour, or you need a separate mixing palette. When choosing between pans and tubes, you will probably find that pans are preferable; when you open the lid every colour is laid out ready to be used. However, you can refill the little pans from tubes and allow them to dry out.

The most important properties of watercolour paints are as follows:
- Pure, bright colours – it is easy to make a bright colour dull, but you can never make a dull colour bright.
- Good translucency – make sure the paints are not

too grainy or chalky.

- Good fixing properties – when you overlay dry paint with a layer of wet paint, some brands dissolve and move, mixing in with the second layer and thus turning to 'mud'. This is very annoying as you want the first layer to stay where it is as much as possible.
- Permanence and lightfastness – you do not want your works of art to fade with age. All paints are graded for their permanence, so try to avoid colours that have a low grade. Remember also that watercolour paintings should not be positioned in bright daylight or direct sunlight.

For most of the paintings in this book I used Winsor & Newton Artists' watercolours, as they were available in my local art shop. Several other good quality brands are available, although note that equivalent colours may have different names. You can order a painted colour chart from most manufacturers, remembering that photographic leaflets do not show the colours accurately.

Colours

For successful flower painting you need a good variety of colours – in particular, reds, pinks, yellows, blues and purples (see the palette of colours overleaf). In theory you should be able to mix any colour from the three primary colours (red, yellow and blue) but in practice this doesn't work, particularly if you want bright and realistic colours.

A tube of White Gouache is also very useful for touching up small details such as veins and stamens. Gouache should be mixed with water to a creamy consistency. As it is opaque it will block out colour, but it should only be used for small, final details as it will cloud watercolours if it mixes in with them.

The colours given overleaf have become my favourites over recent years, although I often try new ones (especially reds and yellows) to try and find the brightest. These are all Winsor & Newton Artists' colours. Other colours occasionally used in my flower paintings are Indian red, crimson lake and oxide of chromium.

Yellows and Oranges: lemon yellow, Winsor yellow, cadmium yellow pale, Winsor orange and bright red.

Reds and Pinks: scarlet lake, Winsor red, permanent carmine and permanent rose.

Violets and Blues: Winsor violet, French ultramarine and Winsor blue (green shade).

Greens and Greys: cobalt green (yellow shade), permanent sap green, Davy's gray and Payne's gray.

Tip

A combination of blue and orange makes a lovely grey. The key here is to experiment with different colour combinations.

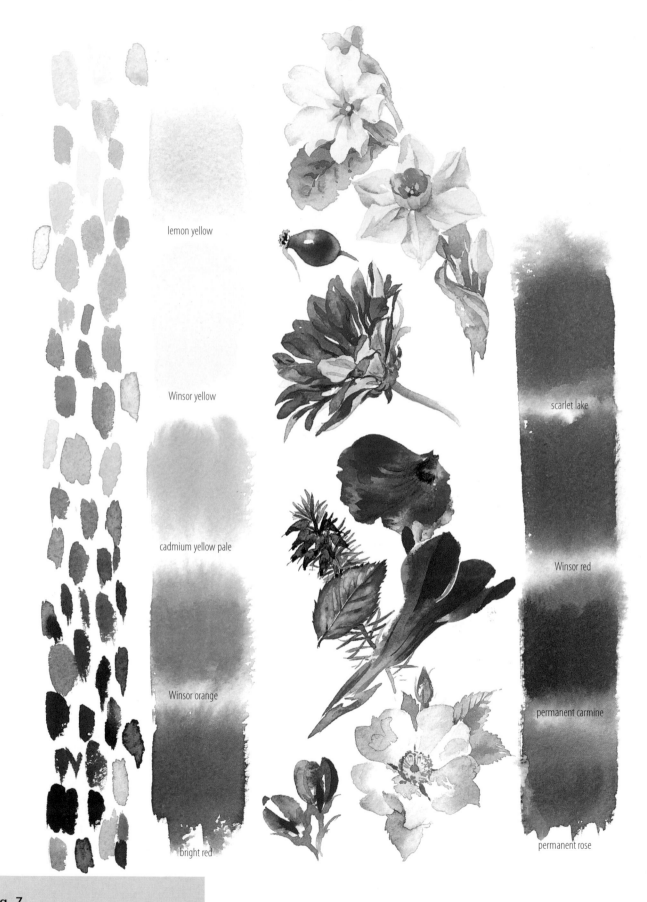

lemon yellow

Winsor yellow

cadmium yellow pale

Winsor orange

bright red

scarlet lake

Winsor red

permanent carmine

permanent rose

Fig. 7

Yellows, oranges, reds and pinks

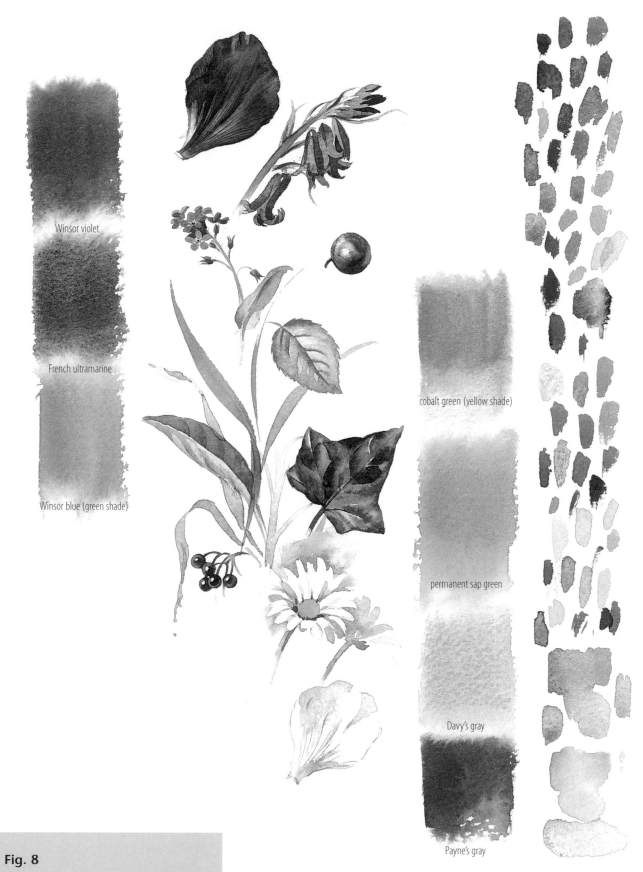

Winsor violet

French ultramarine

Winsor blue (green shade)

cobalt green (yellow shade)

permanent sap green

Davy's gray

Payne's gray

Fig. 8

Violets, blues, greens and greys

Other equipment

Pencil and rubber

I use an HB pencil for the minimum of drawing (see page 8) and a good-quality soft white rubber.

Drawing boards

I have two boards, one measuring 26 x 32 in (660 x 810 mm) which takes an imperial sheet of watercolour paper and one 19 x 25½ in (480 x 650 mm) which takes slightly more than half a sheet of paper or, of course, anything smaller. You will be working life size or larger so a very small board will have only limited use and will give you no room to rest your painting arm.

Two water pots

Use one for clear washes and one for rinsing brushes between colours; jam jars are ideal as you can easily see when your water needs changing.

Kitchen roll or tissues

Useful for mopping paint (toilet paper disintegrates!).

Masking fluid

This is a creamy, liquid-rubber solution that can be used to mask small areas of paper, such as the stamens of a flower, prior to painting. (See also page 72).

Ruling pen

These are used by framers, for the lines around mounts and have a little screw to adjust the width of the line. To be used for fine lines, dots and with masking fluid.

Old brushes

Do not throw brushes away when they are past their best, as you can use them to apply masking fluid.

Brown paper 'gum strip' tape

A roll of this, preferably 1½ in (4 cm) wide, can be used for stretching paper.

Soft sponge or cloth

Use one that holds water well without dripping everywhere for stretching paper.

Experimenting with materials

Of course you don't have to use a brush to apply paint. You could have some fun and try a sponge for texture, a toothbrush for spattering or the edge of a piece of cardboard for printing lines. In fact, you could try anything that might simulate the effect you want without painting every tiny dot and dash individually. With a little ingenuity you can often find a shortcut to achieve the desired effect. For *Seed Heads* (see opposite), marks were made with the following: different thicknesses of cardboard, a ruling pen, the end of a wooden pencil dipped in paint, a small natural sponge and a few strokes of a large brush.

You could also try some unusual papers. I used a lovely rough, hand-made paper for my experiment; made by the Two Rivers Paper Company (see List of suppliers on page 125) it comes in several different shades and, although fairly expensive, it produces lovely effects and is very forgiving, allowing for quite rough treatment.

Fig. 9

Seed Heads
15 x 8 in (38 x 20 cm), 1 hour

CHAPTER 2

PLANNING AND PREPARATION

Time spent planning and preparing ideas and materials before you actually start work
is quite invaluable, so make sure that you develop a routine which means you have
done as much as possible to make the process of painting easier.

What to paint

You don't need a large garden full of beautiful plants to
paint flowers, as there are many other ways to find
material that you can use. Even if you have a large
garden, you may eventually work your way through
every flower, so that you have to start looking further
afield for inspiration. In any case, your choice may be
limited in the winter months. Local florists are often
happy to give you their 'left-overs' (usually in good
condition but with bent or broken stems) for nothing
and market stalls are a good source of cheap flowers.
Bouquets given to me for birthdays or anniversaries
often feature in my paintings; I drop strong hints about
the sort of flowers I like! Two or three flowers can be
painted at once and then again in different positions to
create a whole vase full. With a large garden the options
are obviously more numerous and you have the
advantage of being able to grow your favourite plants
and the species which you would like to paint.

Throughout the spring and summer, there are always
wild flowers in the countryside, but remember that
landowners are entitled to sue for trespass if you pick
flowers on their land or sit on it to paint. It is also illegal
to uproot any wild plant without the landowner's
permission. It is therefore advisable to ask first and only
cut flowers that are in abundance, such as poppies, dog
roses, buttercups and daisies. You should never pick
specimens from nature reserves, nature trails or National
Trust property without permission and you must never
pick or dig up protected species – this is actually a
criminal offence even if they are on your own land.
Approximately 200 plants are specially protected by law
in the British Isles. A list is available from the English
Nature Enquiry Service (see Useful Addresses on page
125 for further information).

Autumn is also a wonderful time to go foraging in
woods and hedgerows for nuts, berries, autumn leaves,
dried seed heads and the like, but remember that even
the verges are someone's property.

Botanical artists need to have access to as many
species as possible. Most people in the horticultural and
botanical worlds appreciate this and are very helpful if
you approach them with regard to painting plants in
their collections. They might cut you some specimens,
loan plants in pots or allow you to paint in their gardens
and are often flattered that their much-loved plants will
be painted for posterity.

Painting style and composition

Even before you pick up a pencil or paintbrush you have
to decide how you are going to use your chosen subject
to make a pleasing composition which will look good on
paper. Spend some time thinking about and planning
your picture before you go charging in and ruin a good
sheet of watercolour paper! A little pencil sketch may
help you to envisage the image and with experience you
may find you can picture it in your mind's eye. Always
start by arranging your flowers in an attractive way – if
they look good in real life they should look good on
paper.

If we all painted flowers in the same way (for
example, in tight botanical studies with white
backgrounds), exhibitions of flower painting would be
incredibly boring. So be adventurous and open your
mind to the enormous possibilities that exist in
watercolour flower painting – especially once you can
handle paint and brushes with confidence.

Fig. 10

Field Poppies
29 x 21 in (74 x 53 cm), 2 days,
brush sizes 8, 6 and 2

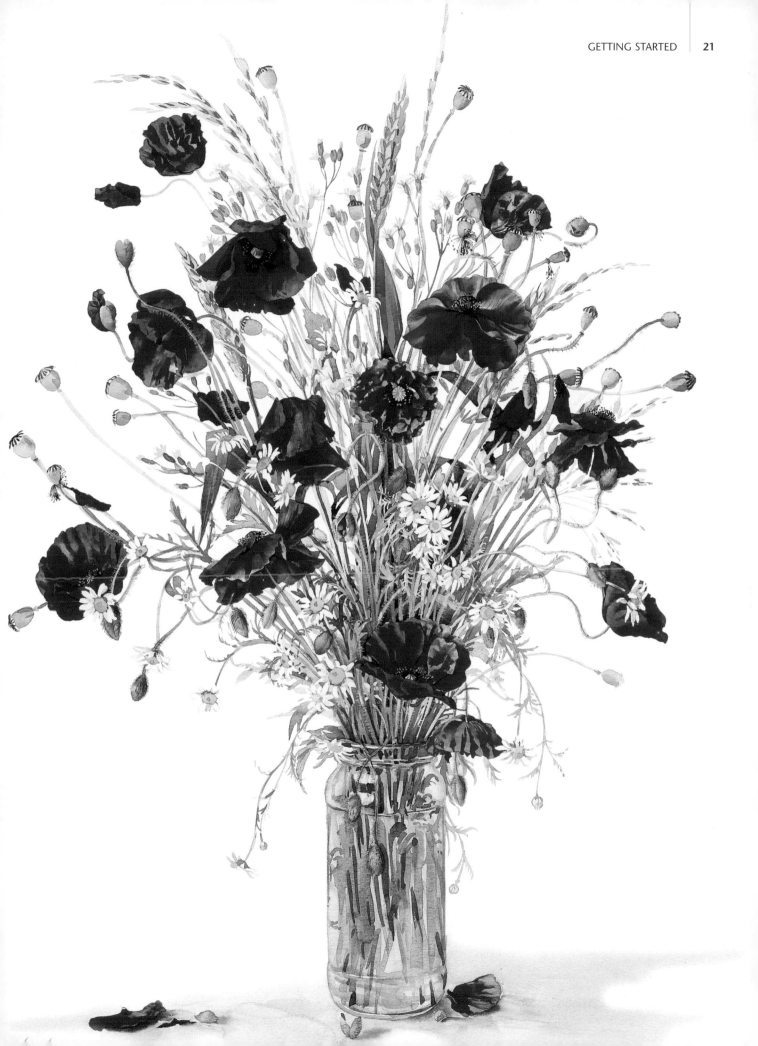

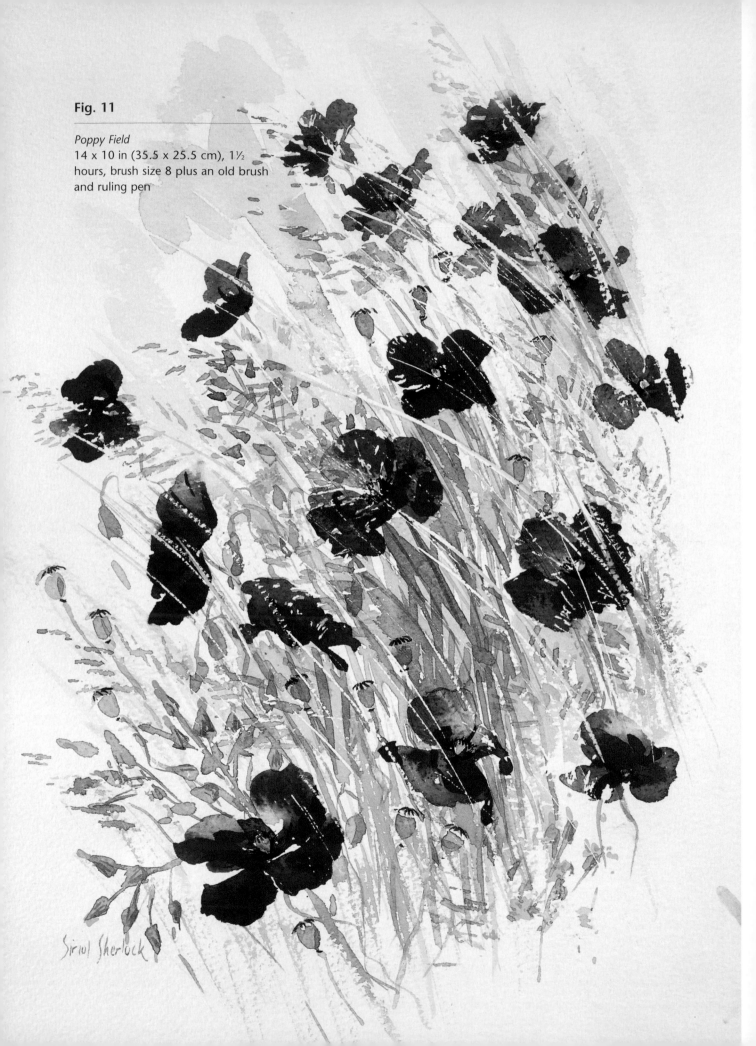

Fig. 11

Poppy Field
14 x 10 in (35.5 x 25.5 cm), 1½
hours, brush size 8 plus an old brush
and ruling pen

When I visit exhibitions of flower painting, the wide variety of subjects, treatments and styles never ceases to amaze me. I particularly remember a painting I saw in an exhibition of The Society of Botanical Artists of a pot of dead daffodils on a window sill! They hung straggling over the sides of the pot, the leaves papery and brown, exactly as in life. Although not a subject you would ever think of, it made an excellent painting because the composition was pleasing and it was beautifully executed. In painting such an unusual subject the artist took a much greater risk than if they had painted pretty living daffodils – but we see so many of those!

Different subjects are treated in many different styles and compositions throughout the book – from a quick impression to a botanical study or a bouquet to a vase of flowers. Each of these are explored in depth later on.

Painting outside

Painting out of doors poses certain problems for the watercolour artist. Ideally you need a seat, something to prop your board or sketch-pad on, a low surface on which to place paints, water pots and brushes, and a sunshade to protect both you and your painting from the sun – the glare of white paper in full sun is blinding and the heat of the sun dries the paint too quickly.

If you sit on the ground under a tree with your knees up, these needs are supplied, but you will soon feel uncomfortable! In the garden you will probably have a table, chair and sunshade to hand already. The problems arise when you go into the field; a lightweight folding seat, an upturned cardboard box on which to place your paintbox and so on, and a light folding easel at which you can sit is ideal. There are lots of easels on the market but most are designed for standing artists and, apart from being tiring for the artist, the boards are held too vertically for wet watercolours which may run.

Poppy Field was painted in the middle of a field on a scorching July day. Streaks of masking fluid were applied with an old brush and a ruling pen to save stalks and grass seeds before painting.

Setting up in the studio

Lighting, sitting position, angle of board and position of subject matter are all very important, as you must feel comfortable in order to perform at your best. What suits one person may not suit another but I suggest:

1 A good source of daylight from your left. This is essential for a right-handed artist – if the light shone from the right, your hand would cast a shadow over your work. Left-handed artists need light from the right. If the light is behind you, your shadow will fall across your work and if the light is in front of you it may silhouette your subject, making it look dark. Bright sunlight shining on your flowers creates interesting shadows and sharp tonal contrasts which can look wonderful in a painting; however this is best avoided when painting a botanical study. Artificial light changes the natural colours and I have found that so-called 'daylight' bulbs give an unnatural look; it is best, therefore, to work only during the hours of daylight and not at all on very dark days!

2 It is best to place your subject directly in front of you, close enough for you to examine the details. It is easy to look up and down from subject to painting; looking from side to side is much more of a strain.

3 Paints, brushes and water pots should be within easy reach to your right if you are right-handed.

4 You should have a blank wall or board, preferably of a pale neutral colour such as cream, behind your subject to screen any distractions. A dark colour behind a floral subject will make the colours of the flowers look lighter; this can be useful, for example when painting white flowers, to make them look whiter and not too grey.

5 In the studio I always paint on a board which rests in my lap and is propped at an angle against the edge of a table. Most easels are too upright for watercolour work causing the paint to run, and if you work on a horizontal plane your vision of the picture will be distorted.

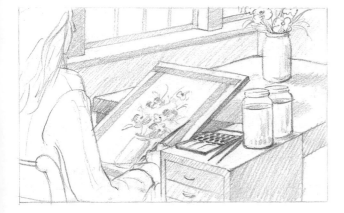

Fig. 12

This shows a good set-up in the studio: light source, materials to hand, subject straight ahead and a tilted board

Stretching paper

Most papers will cockle if the paint is used quite wet. A bumpy painting is very noticeable behind glass and looks unprofessional. A quick, easy method for paper-stretching is as follows:

1 Cut a sheet of paper to a suitable size for your intended picture and place it on your board. Always make it larger than you think you will need, in case the picture 'grows' as you paint.
2 Cut four lengths of brown paper gum strip, two for the short sides and two for the long sides (each one slightly longer than the paper).
3 Soak a clean soft sponge or cloth with water, so that it is almost dripping and gently, but quickly, wipe right across the paper so that it is wet all over, especially the edges. Do not rub.
4 Quickly run one strip of tape, sticky side up, under the wet sponge (if you place the sponge on the edge of the board you can pull the tape through under the sponge). Position the tape along one edge of the paper with half its width on the paper and half on the board.
5 Immediately wipe over this tape with the wet sponge, pressing it down.
6 Repeat steps 4 and 5 for the opposite edge and then the other two edges, gently pressing out the bulging paper as you do so. Allow the paper to dry completely before painting on it; half an hour should be enough.
7 When your finished painting is absolutely dry, cut it off using a metal ruler and a sharp knife. Occasionally you will need to strip away the remaining tape which builds up around the edges of the board.

Tip

If the dry tape is very curly and unmanageable crease it along the length as this will straighten it.

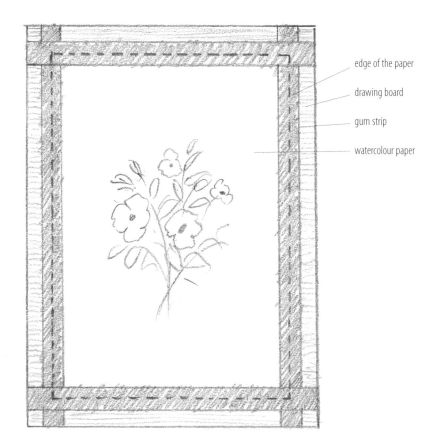

edge of the paper

drawing board

gum strip

watercolour paper

Fig. 13

Stretching paper

Keeping plant material fresh

Keeping plants fresh, upright and alive for painting can be difficult. It is especially worrying if a rare cut specimen is supplied by a botanist and it becomes a race against time to paint the specimen before it wilts. The wild poppy is a classic example of a flower that starts to wilt and whose petals fall as soon as you pick it. For hints on how to overcome these problems see below:

1 When collecting plant material in the field put it straight into a jar of cold water if possible, or wrap the stems with wet tissue. Otherwise, place it in a plastic box or a sealed plastic bag, with a spattering of water if possible. Remember that plant material needs to be kept cool and damp.

2 Wild poppies should be put straight into cold water if possible then when you get them home re-cut the stems and put them into about an inch of boiling water for a minute or two. This also works for roses and probably many other flowers.

3 Pick plenty of buds, as they will gradually open indoors; this especially applies to poppies.

4 If you have some lovely cut flowers, but are not ready to paint them, keep them in a cool, shady room. This will keep them in peak condition for longer.

5 Cut flower food (supplied in little sachets by florists) definitely prolongs their life. My aunt swears by lemonade and a fellow artist recommends the following recipe: 1 dessertspoon of sugar and 1 teaspoon of bleach dissolved in warm water and topped up to 1¾ pints (1 litre) with cold.

6 Always cut stems at an angle, as this allows greater water uptake, and always remove foliage below water level. Re-cutting stems later on often revives wilting flowers (this helped with *Hellebores* on page 59) and cutting hollow stems under water prevents an air lock forming in the stem.

7 To help preserve plant material between painting sessions, place a large plastic bag, sprayed inside with water, over your plant material. If you are using a small specimen, keep it in a damp plastic bag or plastic container in a cool place or the salad drawer of a fridge.

8 To keep the stem ends of plants with a drooping habit (with stems up in the air) in water whilst painting, either (a) wrap wet tissue around the cut stem, (b) use little florists tubes intended for buttonholes (which hold water), or (c) use wet oasis held firmly in a high position so the plant can hang down. For the latter, a colleague of mine has a strong wooden board with a supporting 'foot' and several long nails protruding from the board on which a block of oasis can be impaled; thin wire can be tied to other nails on the board to support a heavy branch.

9 If flowers in a jar are top-heavy and tip over, use Sellotape wrapped around the stem and stuck to the side of the jar to support them.

10 Once you start painting a flower, make sure you finish it – if you leave it half-painted it is bound to have opened, moved or wilted when you return. It is far better to complete just one or two flowers than leave several half-painted.

GETTING STARTED

Actually putting brush to paper can be quite nerve-wracking; many artists are addicted to the use of pencils which make them feel safe before they apply the more unpredictable paint. Do have a go without drawing first and if it doesn't work out the first time, keep trying.

Whether you are a beginner or an experienced painter, it is worth analysing the way you hold your brush, as this will greatly affect the look of your work and your flexibility – both the physical flexibility of your fingers, hand and wrist and the flexibility of your style of painting (see page 28).

To 'warm yourself up', you could begin by freely practising the techniques shown on page 28 on some left-over pieces of watercolour paper before progressing to some reasonably simple flowers like those on pages 31–33.

Always remember to be bold in your use of colour (see Strong contrasts on page 34) – if you use it too pale and too tentatively you will have to build layer upon layer of paint which will destroy the translucent quality of the watercolours.

To draw, or not to draw

The ability to draw is extremely useful. However, while sketching or detailed drawing is a lovely art form in itself, it should be kept to the absolute minimum when used as a component of flower painting – just a few marks, to give an indication of position and scale, are enough.

Preferably, avoid doing a preliminary pencil drawing altogether – when you paint within pencil lines, it restricts the flow of the brush and prevents you from moving the paint where you really want it to go. Omitting the drawing may mean at times that your work is slightly less accurate, but this is more than compensated for by the freshness of the work; with experience you can become very skilled and accurate at using a brush without any guidelines at all. If you do draw first, an HB pencil is most suitable; do not use a very soft, smudgy pencil or a very hard one which might leave indentations on the watercolour paper. Draw very faintly, as pencil lines are difficult to erase once you have washed over them with watercolour; to make them even fainter prior to painting, press a clean rubber against the lines as this lifts a little of the carbon without rubbing out the lines completely.

Draw as often as you can to improve your speed and skill. This will help your brush skills and improve your hand to eye co-ordination. This sketch (right) was done with a water-soluble pencil so that tones could quickly be added with a wet brush. To get the darkest tones wet the paper first, then add pencil.

Fig. 14

Seed Heads
water-soluble pencil

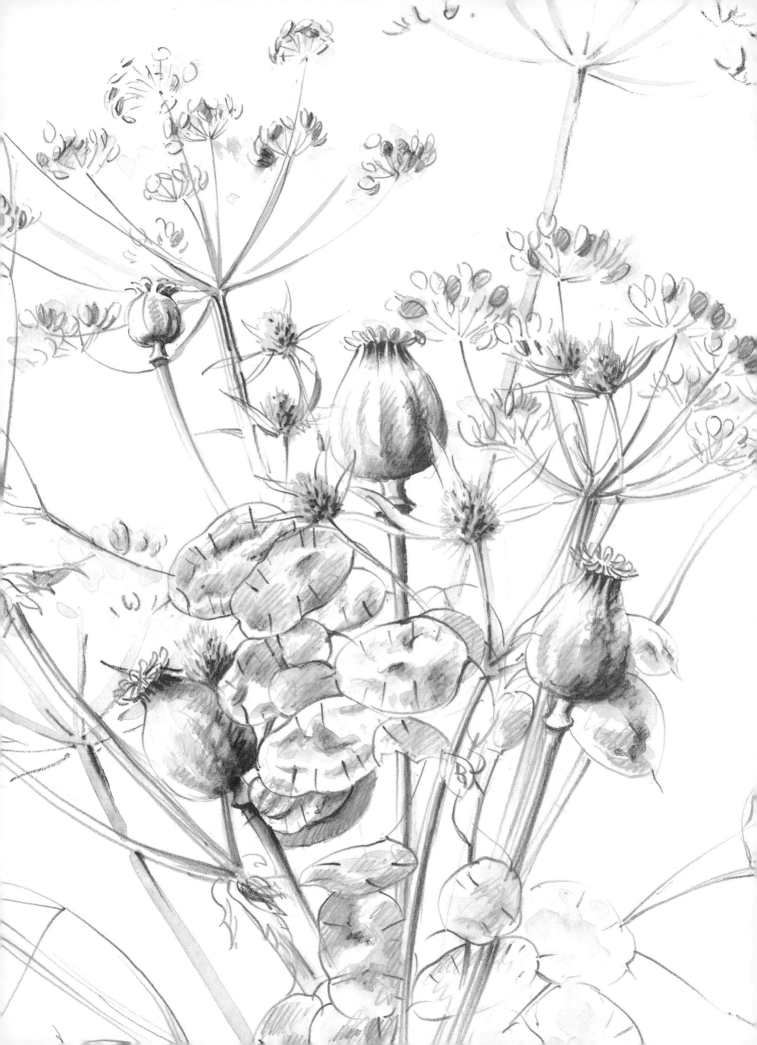

Holding the brush

The way you hold your brush greatly influences your style of painting.

1 If you hold the brush tightly at the bottom of the metal ferrule just above the hairs, you will have very limited flexibility. You will tend to use the tip of the brush with tiny brush strokes and little stabbing motions, and you will probably rest your fingers on the board which makes your hand very rigid. This is good for tiny details, but that is all.

2 If you hold the brush further up the ferrule, your fingers will be free of the paper so that your hand can swivel from the wrist (which is resting on the board) and can glide across the board. This gives you more flexibility and allows flowing brush strokes while at the same time giving a good degree of control.

3 If you hold the brush well up the handle this gives great freedom of movement but not much control. Your hand and wrist will be suspended above the board allowing for great speed and spontaneity. With practice you can become very skilled at this style of painting, but it is unsuitable for botanical studies.

I use methods 1 and 3 at times, but most of the time I use method 2.

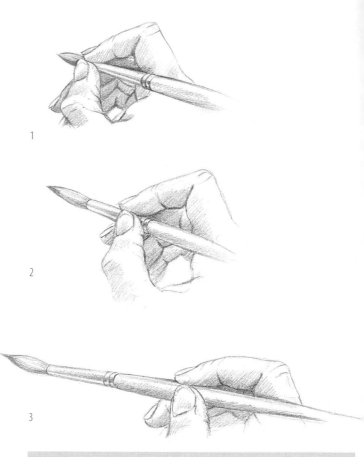

Fig. 15

Holding the brush

> ### Tip
>
> Place a sheet of paper or tissue under your hand if it is resting on the painting, especially if you use hand cream or have clammy hands – a greasy surface repels watery paint.

Painting techniques

There are many ways of applying paint to paper with a brush. The chart opposite shows a breakdown of the individual techniques frequently referred to in this book. Analysing painting in this way makes it seem very clinical but you will find that these techniques become automatic and blend into one another as you are painting a picture. The three techniques listed here are the most vital to master:

Wet-on-wet

This simply means adding paint to wet paint which is already on the paper or to clean, wet paper, thereby allowing colours and water to blend on the paper. This technique can seem rather uncontrollable and in fact it can be used to create exciting, random effects; however, with experience you can learn to control both paint and water and get them to do exactly what you want. This really is the essence of watercolour painting.

Wet-on-dry

Laying wet paint on paint that has dried or on dry paper. This produces sharper shapes which do not blend together, as in wet-on-wet.

Softening

This involves softening and blending out colour while it is wet with a clean wet brush so that the paint doesn't form a hard edge.

Wet-on-wet – adding water
to wet colour on the paper

Wet-on-wet – adding colour
to water on the paper

Wet-on-wet – adding
colour to wet colour

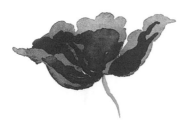

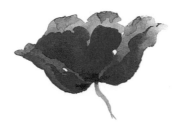

Wet-on-dry – layering
wet paint on paint that has dried

Wet-on-dry – a layer
of wet-on-wet over a dry layer

Dry brush stroke – working paint off
the brush to give textured brush strokes

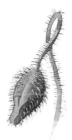

Lifting colour – with a damp
brush while paint is wet

Lifting colour – after the paint has dried,
with a wet brush and a tissue to blot the paper

Split hairs – spreading the
hairs of a small brush (see page 46).

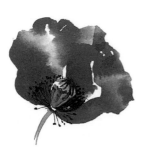

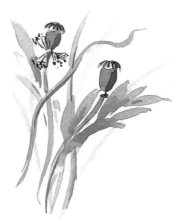

Dots and dashes – with the
tip of a small brush

Softening – using a wet brush to blend
out hard edges before the paint dries

Simple brush strokes –
using a stroke of the brush

Mixing colours

Some of the paintings in the book are accompanied by a colour palette to show how colours were mixed. With experience you will soon learn that a dab of red will tone down green, that blue and orange make a lovely grey or a touch of Winsor violet added to French ultramarine is perfect for bluebells, and so on. These few examples show how a dab of this or that changes the main colour. Of course, there are thousands of ways to mix the colours you need; you don't have to stick to any strict rules, but try not to use too many colours to reach a particular hue or you could end up with very muddy colours.

Tip

- Always test colours on scraps of watercolour paper before painting; allow to dry and then compare to the actual colour of the plant. Colours usually dry weaker and duller, so keep them strong.
- Pre-mix pools of the main colour washes; using strong colours doesn't mean they should be used dry.

Fig. 16

Mixing colours

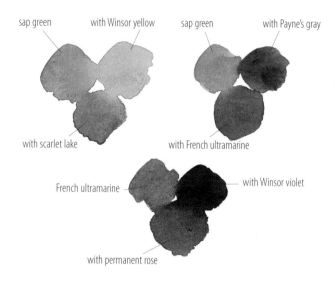

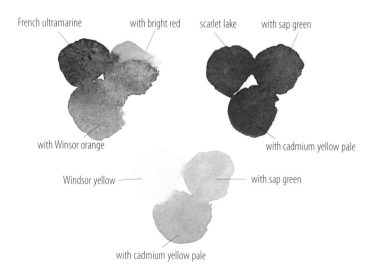

Using the techniques – four simple flowers

These flowers, *Anemone*, *Freesia*, *Tulips* and *Pansy* were painted quickly using most of the techniques shown on page 29. None of them was drawn first, but if you are petrified at the thought of putting a loaded brush of colour onto a clean sheet of paper without any pencil lines to guide you, then put in a few guidelines if you must! Drawing each flower fully would waste valuable time and is unnecessary. Remember, if you fully draw the flower first you will just fill in the outline with colour and the paint will have no vitality.

When painting, always remember two of the Secrets of success (see page 8): let the paint flow and use the translucency of watercolour (the latter does not apply to *Pansy* where the paint is used very strong and opaque).

Brush sizes 8 and 10 were used throughout, with size 5 for the smaller details of the anemone and pansy.

Anemone

Colours

Petals: Winsor red, permanent carmine, Payne's gray
Centre: Winsor violet, Payne's gray
Sepals: sap green, French ultramarine, Payne's gray

Method

1 Wet an area approximately 1½ in (4 cm) in diameter and with the larger brush quickly paint the red petals around the wet area so that tips of the petals are sharp against the dry paper, but colour blends into water towards the centre wet-on-wet. Do not allow colour to run too far into the centre, or you may lose the white area completely – control it by lifting off colour with a clean damp brush if necessary.

2 Add darker colours to petals wet-on-dry, picking out individual petals and softening edges where necessary with a clean, wet brush.

3 Paint the dark central 'ball', then drop a little clear water into the centre, wet-on-wet to push the darker paint to the edges, thereby giving it a rounded look. You could also get this effect by lifting off colour with a clean damp brush to give a soft highlight in the centre of the ball.

4 With the tip of the smaller brush, add dots and dashes for the stamens and fine lines on petals.

5 Quickly add the curly sepals with simple brush strokes.

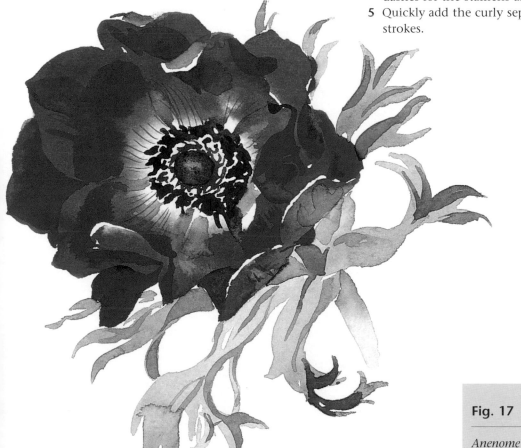

Fig. 17

Anenome

Freesia

Colours

Flowers: cadmium yellow pale, scarlet lake, Winsor red, permanent carmine
Sepals and stem: sap green, Winsor yellow

Method

1 Working on one flower at a time, paint the main body of the flower in yellow and quickly add red to the tips of the petals wet-on-wet, letting the red merge into the yellow.
2 Leave tiny gaps so that you can work on other petals without the paint running into earlier ones, which may not be dry. This saves time if you are in a hurry.
3 Paint the buds next, again adding colours wet-on-wet.
4 Finish by painting the green sepals and stem.

Tips

- Pre-mix pools of the main colour mixes. This avoids delays which would otherwise interrupt your 'flow'.
- Keep a fairly large spare brush at hand to use for clear water; hold any spare brushes in your non-painting hand ready to swap over.
- You must let the paint dry between stages, or all the colours may run together to make 'mud'.
- If you are only working on one flower, a hairdryer will speed up the drying process. If you are working on more than one flower, you can move around the painting – there is always something to be worked on, so you need never sit and watch the paint dry!

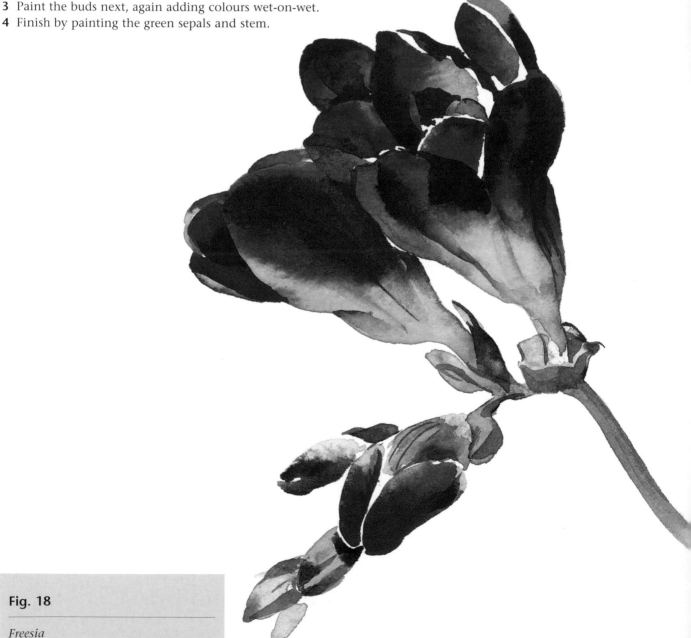

Fig. 18

Freesia

Tulips

Colours

Winsor yellow, scarlet lake, Winsor red, permanent carmine, sap green

Method

1 Working on the front flower first, paint pale yellow outer petals and add streaks of red, wet-on-wet.
2 While still wet lift off colour with a clean damp brush to give the effect of a sheen.
3 When the outer petals are dry, paint yellow inner petals adding red and touches of green wet-on-wet.
4 Repeat stages 1–3 for the back flower.
5 Add dry brush strokes of stronger reds to give streakiness to the petals.
6 Finally add the stems and leaves with quick simple brush strokes.

Fig. 19

Tulips

Pansy

To achieve the rich, velvety appearance of the pansy, it is important to use strong colour.

Colours

Cadmium yellow pale, permanent carmine, Winsor violet, Payne's gray, sap green

Method

1 Starting with the lower petal, paint a wash of yellow and quickly add strong carmine around the edge of the petal, blending it into the yellow wet-on-wet. Add some darker tones while the paint is still wet but do not overwork it.
2 Paint the two side petals, making sure you leave the tiny white lips in the centre, and add some darker tones.
3 Paint the top two petals in the same way, ensuring that they are sufficiently dark against the paler edges of the lower petals.
4 Gently lift colour after the paint has dried with a damp brush to give a velvety sheen.
5 With a strong carmine, violet and Payne's gray mix, use gentle dry brush strokes to give a rich, velvety texture. These can also hide any serious defects!
6 Paint the small details in the centre and add the fine dark lines with the fine tip of the smaller brush.

Tip

If you have not achieved enough sheen on the petals, use a clean wet brush to loosen some of the colour and quickly dab with a clean tissue to lift off more colour.

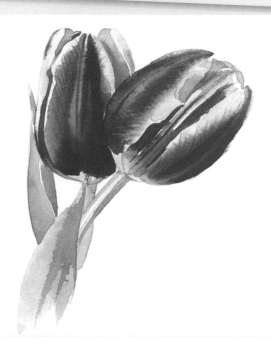

Tips

• Be gentle when over-painting strong, thick colours like those in the pansy, as they are easily disturbed by subsequent layers of paint and can end up looking very streaky.
• When using strong colours you must still mix pools of colour and keep your paint wet enough. Don't try to paint 'dry' (except when using dry brush strokes), as you will not be able to achieve wet-on-wet effects.

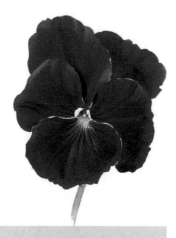

Fig. 20

Pansy

Strong contrasts

Wishy-washy paintings seem to fade into the background like wallpaper – they don't make an impact. A painting which has strong contrasts jumps out at the viewer and comes to life.

There are three types of contrast which are important to bear in mind with flower painting:
- contrasts between different colours (hues)
- contrasts between light and dark (tones)
- contrasts between shapes and sizes of flowers and leaves

Spring Border

The painting, *Spring Border*, shown on the next page and overleaf, has all three types of contrast. The different hues contrast strongly with each other, there are lots of tonal contrasts and there are different shapes and sizes of flowers and leaves. In the detail shown here, the tone of the dark green contrasts strongly with lighter reds and yellows, making the lighter narcissi and primula leap out of the paper and the leaves appear to be behind the flowers, in the background. At the same time the contrasting hues of blue, orange, yellow and green spark each other off.

These hyacinths, primulas and miniature narcissi were bought to go in a large tub by my front door. I wanted to paint them in the tub out of doors but it was much too cold, being the end of February, so I decided to make them look as if they were growing in a border. I chose these flowers because I loved the contrast of the bright blues, yellows and oranges. Blue and orange are complementary colours, that is, they are complete opposites in the colour spectrum. Complementary colours usually do spark each other off, and in theory they should also make grey when mixed together which is very useful for shadowy greys.

Colours
Winsor yellow, cadmium yellow pale, Davy's gray, bright red, scarlet lake, French ultramarine, Winsor violet

Method
It is sensible to paint all flowers of one colour at a time, so that you don't keep changing the colours on your brush and dirtying the water. This is not a strict rule. I got bored with narcissi after I had painted a few and returned to them later. A mixture of brushes size 10, 8 and 5 were used.

1 The central orange primulas were painted one at a time with a Winsor yellow wash, adding scarlet lake and bright red, wet-on-wet. It was important to make sure the central yellow 'stars' were not lost. Central details were then added with a small brush.

2 The narcissi petals were painted with Winsor yellow, their trumpets with cadmium yellow pale and shadows on the petals with Davy's gray.

3 A few leaves and stems were added at this stage to hold things together, but only where I was sure this wouldn't interfere with any flowers I might wish to add.

4 The hyacinths were painted with a flowing wash of French ultramarine and Winsor violet, starting pale and adding stronger colour as it dried.

5 The painting was extended to the right by adding the yellow primula.

6 Leaves and stems were added quite freely, but at the same time it was important not to paint over the flowers.

7 Little speedwell flowers were dotted here and there and some sharper details added.

Tips

- To keep colours like these pure and bright, you must change your water frequently; even a hint of another colour will dull a bright yellow, red or blue.
- If you are right-handed, start painting from the left at each stage, so that you don't put your hand in the wet paint. For example the left hyacinth was painted before the others. The opposite is correct for left-handers.
- It is easy to go overboard with colour contrasts when painting a mixture of flowers. As a general rule, if flowers look good together in a vase or a flower bed they should look good together in a painting. Beware of clashing reds, purples, pinks and oranges such as you might find in a bunch of asters or dahlias, they can look awful together in a painting.
- A mixture of flowers with a colour theme, for example different shades of pink, usually works well but you must have enough tonal contrast or it could look like candy floss!
- A painting like *Snowdrops* (shown on page 70) relies almost completely on tonal contrasts. The colours (or hues) are very close to one another and it is the tonal contrasts that make the flowers stand out.

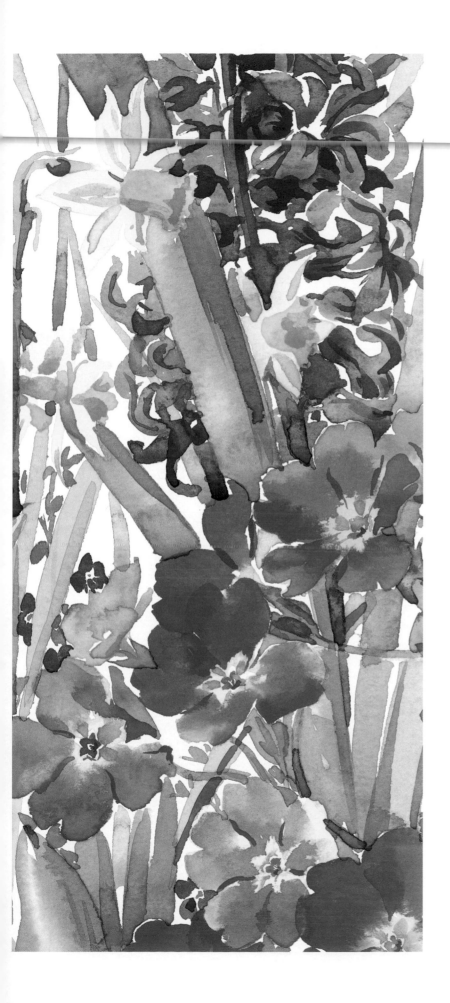

Fig. 21

Spring Border (detail)

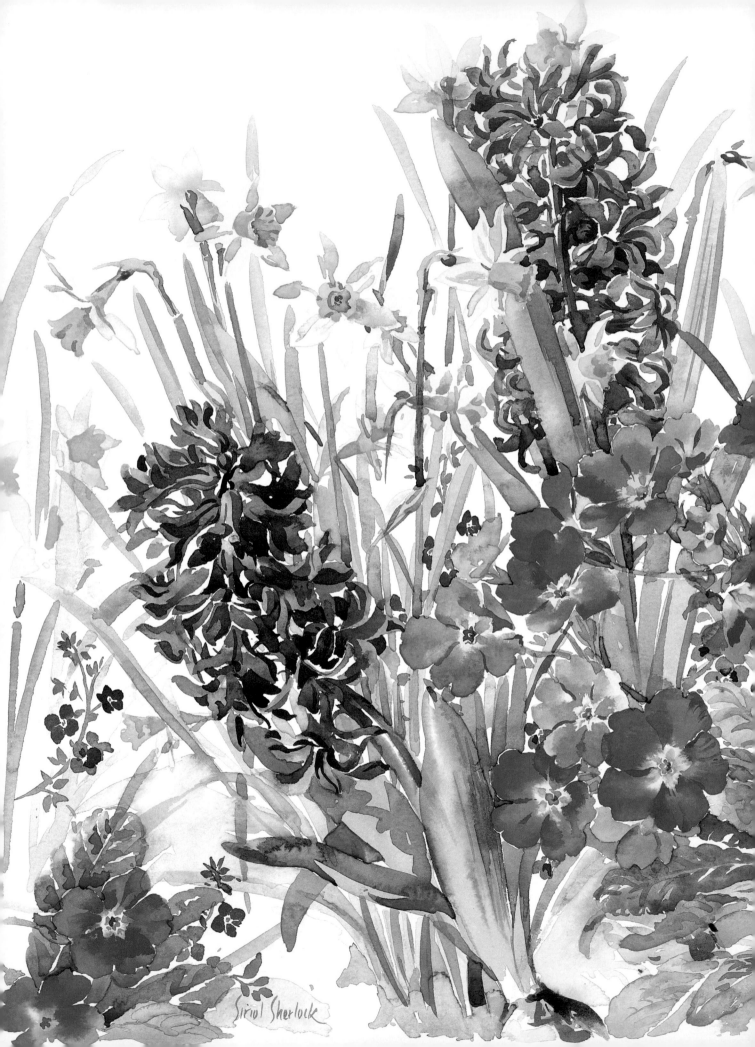

Siriol Sherlock

Fig. 22

Spring Border
15 x 20 in (38 x 51 cm), 1½ days,
brush sizes 10, 8 and 3

CHAPTER 4

PAINTING STYLE

Choosing a style and composition to show off your subject beautifully needs some thought – there should always be an element of design in your paintings. If you paint exactly what you see in front of you, it may not make a pleasing design.

A quick impression or a detailed study?

Painting quick impressions and detailed studies present two different challenges for the artist. Although many floral artists specialise in one style of painting, there is no reason why you should not paint in many different ways, and for that matter, different media. Often the character of a plant dictates the most suitable style. Painting a very detailed study can give you great satisfaction, but consider whether it is worth spending days on one painting when it is possible to catch that freshness and beauty in a few hours. An overworked, laboured painting is also in danger of losing the vitality of the living flower.

Throughout the book you will find examples of 'quick' and 'slow' paintings and many which fall in between the two categories. However, there are only one or two examples of 'very slow' paintings as, unlike some botanical artists, who will happily work on one painting for weeks, my patience is limited.

Bluebells – quick and slow

The character and shape of bluebells is perfect for a quick painting. With a swish of the brush and a little courage you can capture those curled back petals, long smooth stems and pointed buds with simple brushstrokes. It is much more difficult to capture their beauty in a detailed painting. The whole bunch of bluebells illustrated opposite was painted in much less time than the two stems shown on the right.

Tips

- A faint pencil line for each stem will guide your brush if you are really worried about going straight in with paint, but why not try without a pencil?
- Paint most of the flower heads before adding the stems and leaves; remember you cannot paint flowers over stems or leaves.

Colours
Winsor Yellow, French ultramarine, permanent sap green, Winsor violet

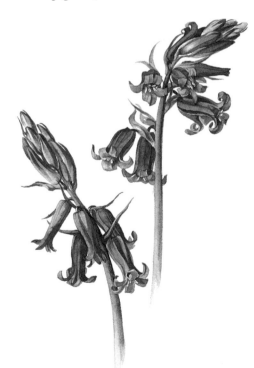

Fig. 23

Bluebells
5 x 3 in (12.5 x 7.5 cm), nearly 3 hours, brush sizes 6, 5 and 2

Fig. 24

Bunch of Bluebells
9½ x 9½ in (24 x 24 cm), 1½ hours,
brush sizes 10 and 8

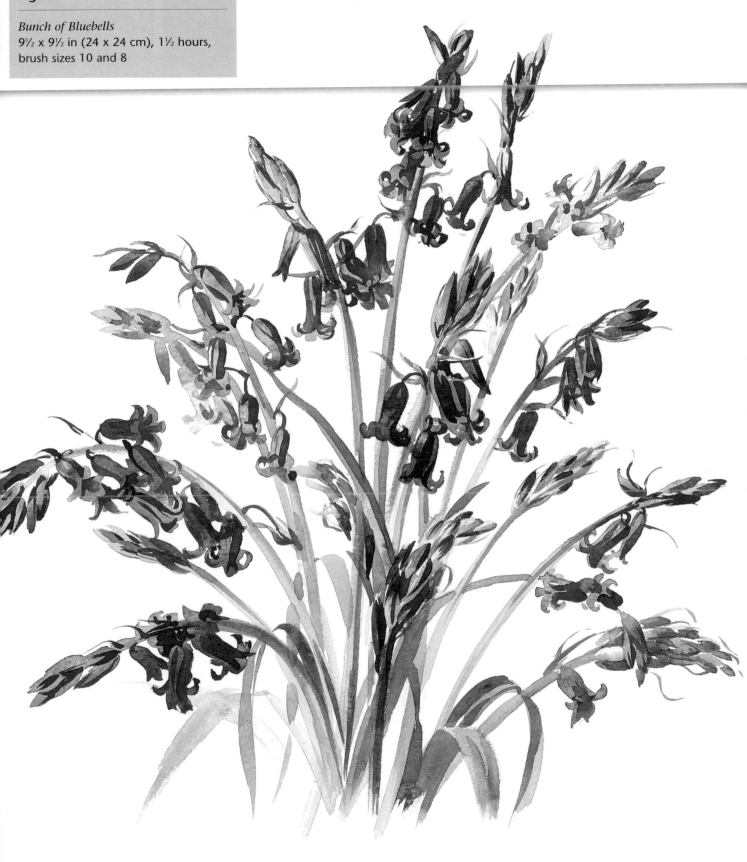

Quick paintings

If you can learn to capture the essence of a plant in limited time, you will have attained a great skill. You have to paint fast and loose to achieve this. Loose work is not an excuse for sloppy painting – there is a world of difference between a splodge that just looks like nothing and a controlled splodge that looks like a petal. Three good reasons for learning to paint in a 'loose' style are listed below:

- If you are used to working very 'tightly' with tiny brushes and in great detail, it can be very difficult to loosen up your style. On the other hand, if you start to paint 'loosely' it is not so difficult to tighten up when the need arises.

- If the painting doesn't work out, you will not have wasted hours of hard work!
- You don't need to have a clear day (or week) set aside to achieve results. A couple of hours here or there may be enough. Remember, you should not value a painting by the number of hours it took to paint.

Parrot Tulips

A quick, loose impression is the perfect way to capture the character of flowers such as poppies and the shaggy *Parrot Tulips* shown opposite. I wanted some roughness of texture, so I chose Waterford Rough paper.

Colours
Winsor yellow, Winsor orange, bright red, Winsor red, permanent carmine, Winsor violet, French ultramarine, sap green

Method
1 The paper was wetted for the front flower and some yellow was dropped in, wet-on-wet.
2 As this was drying, some red and green streaks were stroked in.
3 When the first layer had dried (with the help of a hairdryer, as this paper is slow to dry), I added the bolder reds, purples and greens.
4 Once the first flower had dried, I painted the second, making sure there was a sharp contrast where the two flowers met, so that the first flower was thrown forward.
5 Finally, the stamens, stems and leaves were added.

Tips

- Use a large piece of paper, as a small piece will constrict you, thereby causing you to work small and 'tight'.
- Remember to mix pools of the main colours ready to use at speed.
- Set yourself a time limit (1 or 2 hours) to finish the whole painting – it really concentrates the mind.
- Don't worry if the painting looks unfinished at the end of the time limit, if you mess about with it you will lose the freshness.
- Practise 'speed exercises' with many different flowers.

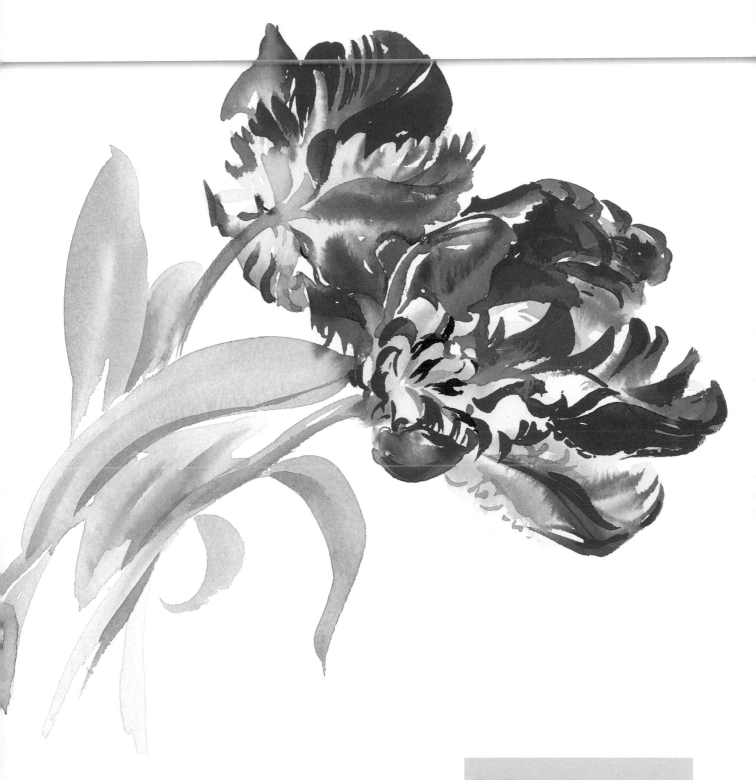

Fig. 25

Parrot Tulips
10 x 10 in (25.5 x 25.5 cm), 1 hour,
brush sizes 10 and 14

Apple Blossom

Immediately after I painted this branch of apple blossom, a severe night frost destroyed every bloom on the tree. Luckily I had chosen to do a quick painting which was finished in one go and I did not need to cut further specimens of the apple blossom. Springtime can be a frustrating time for floral artists – as soon as the warmer weather comes, everything bursts into flower. Suddenly there is so much to paint and it is hard to choose. It is advisable to paint tender flowers such as blossoms, magnolias, camellias and rhododendron at the first opportunity, in case a hard frost turns them brown.

Colours
Lemon yellow, scarlet lake, permanent carmine, French ultramarine, permanent sap green, cadmium yellow pale

Method
1 Using good quality large brushes with that essential fine point, the flowers were painted first (do not be tempted to add leaves and stems too early as you cannot paint flowers over them).
2 The brushwork flowed quickly, moving from one flower to another and then back again as the paint dried, adding a touch of detail here and there.
3 The leaves and branches were painted last, adding dark greens and browns to lighter washes wet-on-wet on the paper.

Fig. 26

Apple Blossom
8 x 16 in (20 x 40.5 cm), 2½ hours, brush sizes 10 and 8

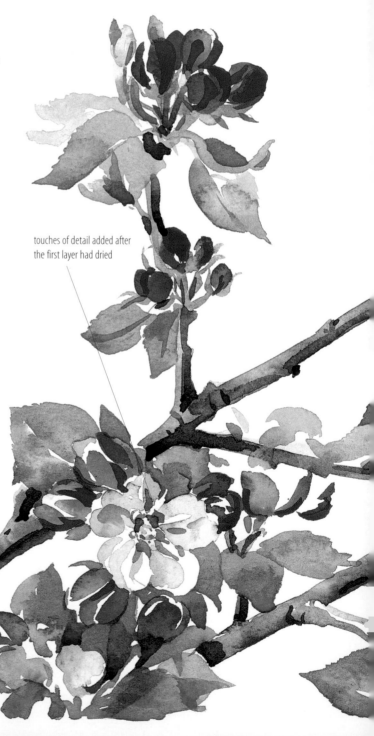

touches of detail added after the first layer had dried

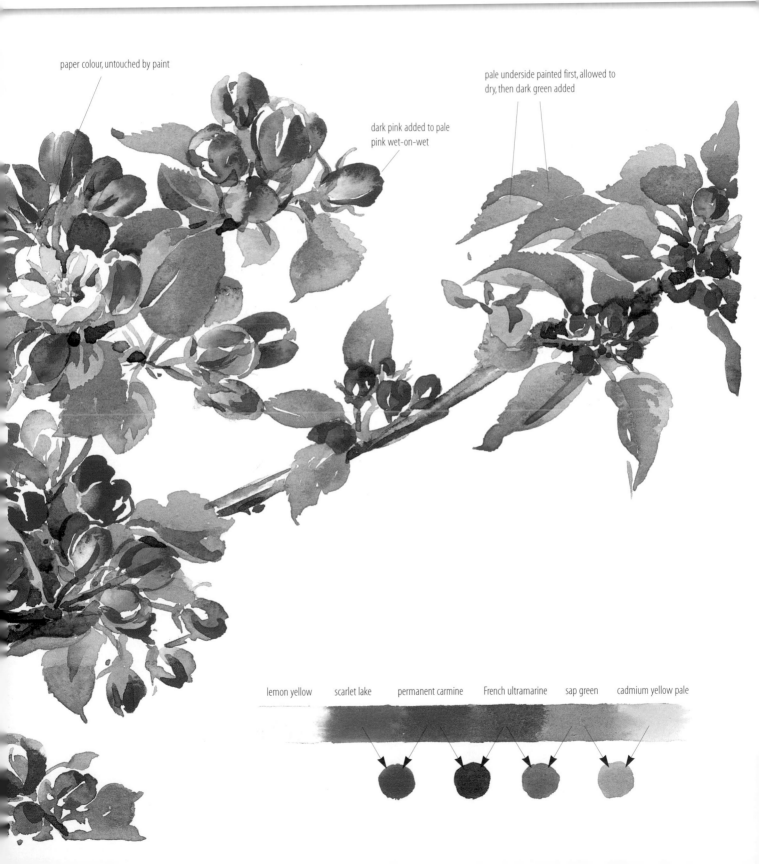

paper colour, untouched by paint

pale underside painted first, allowed to dry, then dark green added

dark pink added to pale pink wet-on-wet

lemon yellow scarlet lake permanent carmine French ultramarine sap green cadmium yellow pale

Oriental Poppies

This is another flower that is perfect for a quick painting. Poppy petals are floppy and ragged, so they don't need great accuracy and it would be difficult to keep their amazing colours so bright and fresh in a detailed, overworked painting. Using the paint very wet allows the paper to shine through the colour and gives it luminosity. I used brushes size 10 and 8 and flooded the paint in, very wet.

Colours
Winsor orange, bright red, scarlet lake, Winsor red, permanent sap green, Winsor violet, Payne's gray, white gouache.

Method
1 The whole flower shape was painted with a wash of bright red and darker reds were added, wet-on-wet.
2 A stronger wash was overlaid, wet-on-dry, to begin separating petals.

Fig. 27

Oriental Poppies (stages 1–5)

3 Violet was added to a green wash, wet-on-wet.

4 Orange and red were dropped into a clear wash, wet-on-wet.

5 A bright red wash was painted and streaks of darker red were added wet-on-wet. Touches of green were dropped in while this area was still wet.

6 Darker red was painted, wet-on-dry, softening edges where necessary with a damp brush.

7 A Winsor red wash with Payne's gray was dropped in

wet-on-wet.

8 Payne's gray details were added.

9 Dry brush work using strong Payne's gray was added to give the impression of pollen.

10 The paper was wetted first for a soft effect.

11 As a final touch, white gouache was used to suggest the hairs.

Winsor orange, bright red, scarlet lake, Winsor red, permanent sap green, Winsor violet, Payne's gray

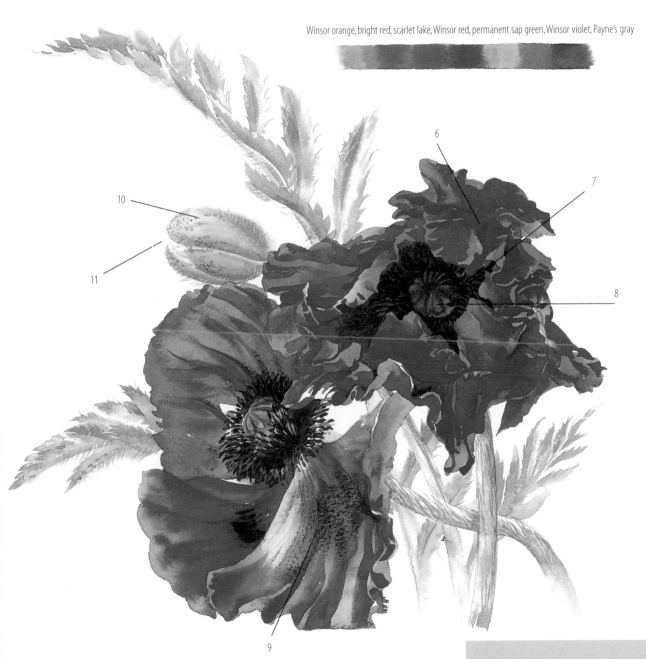

Fig. 28

Oriental Poppies (stages 6–11)
10 x 10 in (25.5 x 25.5 cm), 5 hours,
brush sizes 8, 6 and 3

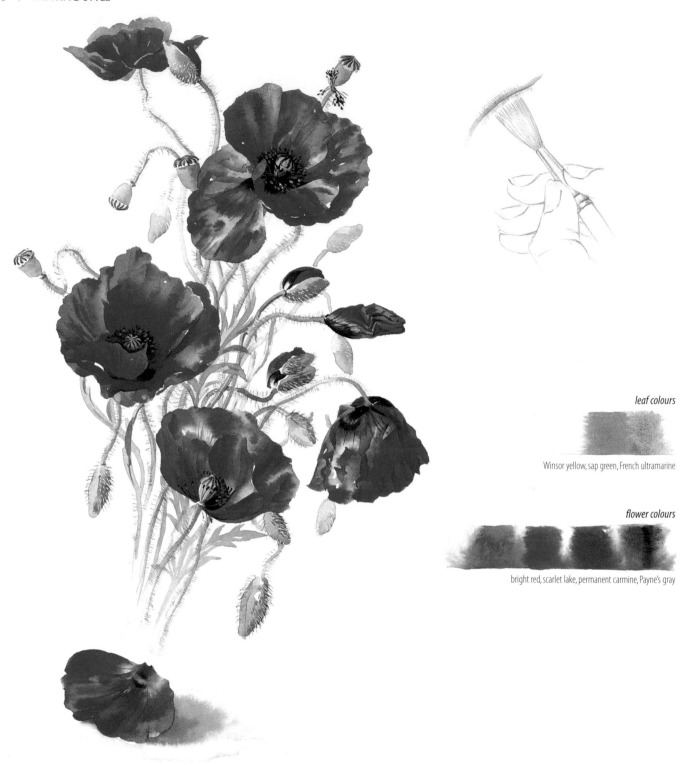

leaf colours

Winsor yellow, sap green, French ultramarine

flower colours

bright red, scarlet lake, permanent carmine, Payne's gray

Fig. 29

Poppies
10 x 6 in (25.5 x 15 cm)

Wild Poppies

Poppies never cease to be popular, but it is a sad that such a beautiful, evocative and fragile flower is often so badly painted. They need to be painted quickly as they tend to droop and lose their petals. The petals have a wonderful sheen and translucency that can easily be captured in watercolour. The secrets are to use the brightest reds you can find, to let the white paper glow through the paint and not to overwork the paint, or you will lose that essential translucency.

Colours
Winsor yellow, permanent sap green, French ultramarine, bright red, scarlet lake, permanent carmine, Payne's gray

Method
(for a single flower)
1 The central capsule was painted in pale green, adding a touch of darker green wet-on-wet. The first petal was painted with water and then reds were dropped in wet-on-wet.
2 The stronger red petals were painted, with touches of deep carmine added, wet-on-wet. The buds and stems would normally be painted after the flowers, but here the first stage was completed.
3 Deep reds were painted around the paler inner petals which made them stand out. Crinkly grey shadows were added, then the black blotches and final details on the capsule. The stamens were painted with a white gouache and Payne's gray mix.

Tips

• Payne's gray used strong, but wet, makes a wonderful rich black.
• For a short-cut to avoid painting each individual hair on hairy stems, dip a medium-sized brush in paint, then flatten and spread the hairs. Work off some paint and you should be able to paint lots of hairs with each brush stroke (see illustration opposite).

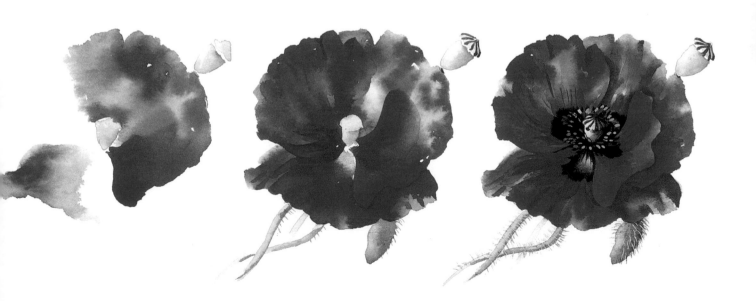

Fig. 30

Wild Poppies (stages 1–3)

Sweet Peas

Watercolour is the perfect medium for those wonderful
undulating, translucent petals and pure, bright colours.
But nature, with the help of man, has created the
deepest, richest crimsons, purples and blues which are
impossible to re-create in paint. It is very frustrating, but
the artist is always restricted by the palette of colours
available and it is almost impossible to mix such
brilliant colours; you just have to do the best you can.
Sweet peas will be ruined by overworking, they are
wonderful when painted very freely, so use quite large
brushes and remember to let the paint flow.

Colours
French ultramarine, Winsor violet, permanent carmine,
permanent rose, scarlet lake

Tips

- Keep changing your water, as the slightest tinge will dull
 such pure, bright colours.
- For the tendrils, use a fine brush (size 2 or 3) and try to
 paint them with one sweep of the brush. If you paint them
 tentatively, you will end up with a very shaky line. See
 page 28, (fig. 2), for the correct hand hold. Darken one
 side to make them three-dimensional.

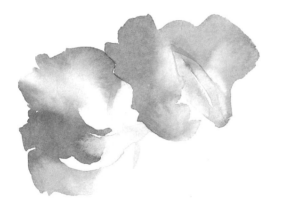

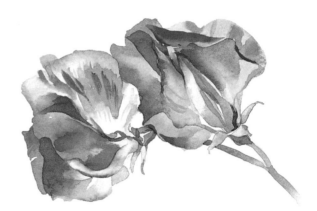

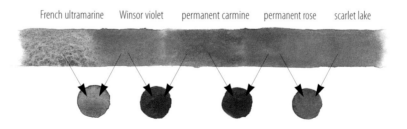

French ultramarine Winsor violet permanent carmine permanent rose scarlet lake

Fig. 31

Sweet Peas (stages 1–2)

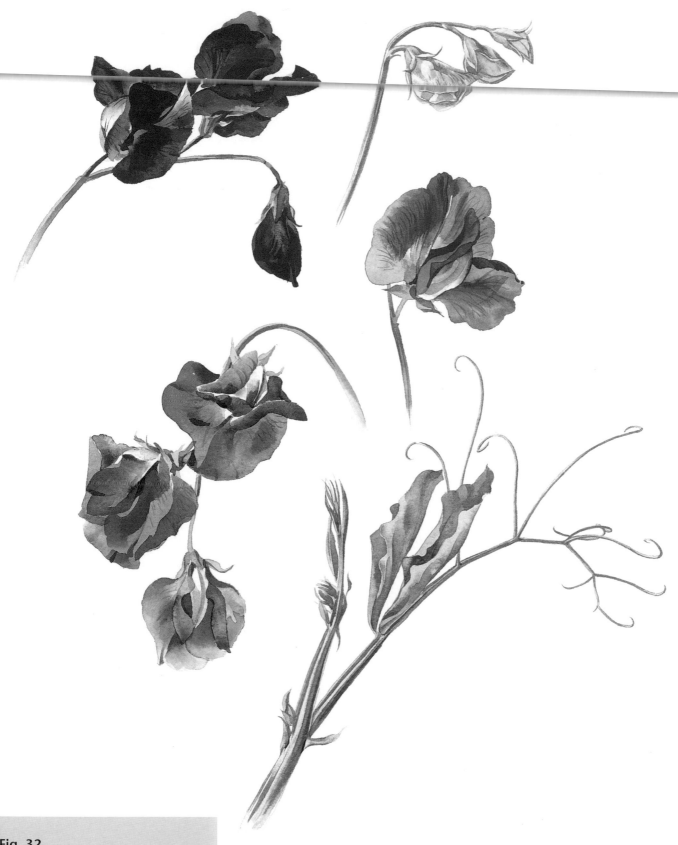

Fig. 32

Sweet Pea studies, one day,
brush sizes 8, 6, 2

Freshness and spontaneity

Try to retain that freshness and spontaneity when you move on to more complex compositions. *Wild Primroses* might look complicated, but if you follow the rule of painting the lightest colours first and darkest last, it should work out – you can always hide mistakes with darker colours!

It was painted quite fast and loose, but the dark greens and browns around the primroses were dropped in more carefully after pencil outlines had been drawn around the pale flowers. I quite often draw a quick pencil outline around pale or white flowers after I have painted them so that I don't 'lose' the edges of the petals; darker colours can then be painted around the flowers even after the flowers have wilted.

This primrose was rescued from an old flowerbed, put it in a pot and brought it in to paint before it was transplanted. Remember you should never dig up plants in the countryside (see page 20). As it was potted, there was no danger that the flowers would wilt.

Wild Primroses

Colours
French ultramarine, sap green, scarlet lake, cadmium yellow pale, Winsor yellow, Davy's gray

Method
1 Pale yellow was washed in fairly freely for the primroses, adding touches of grey wet-on-wet.
2 Hard edged grey shadows were overlaid on the flower wet-on-dry, and softened where necessary with a wet brush.
3 The flower outlines were pencilled in.
4 Cadmium yellow details were added and softened with a damp brush.
5 The green centres and sepals were added.
6 The paper was wetted around the flowers with a large brush and pale beige, lemon and green background

tints were dropped in up to the pencil outlines.
7 When it was dry, spidery grasses were sketched in with masking fluid using a ruling pen and brush (see Masking fluid on pages 72–6) and left to dry for a few minutes.
8 The primrose leaves were painted around the flowers adding colours wet-on-wet, then the ivy leaves were painted. The contrast of the strong greens immediately threw the pale primroses forward.
9 Dead leaves and grasses were painted freely over the masking fluid, but working carefully around the primroses.
10 Dark shadowy contrasts were added to throw the leaf shapes forward.
11 When the whole painting was absolutely dry, the masking fluid was rubbed away and any harsh lines were softened with a damp brush.

Tips

• Use a very pale yellow wash for primroses – mostly water with a touch of Winsor yellow or lemon yellow.
• By using fairly large brushes, you will not get bogged down in too much detail and will be forced to work loose.

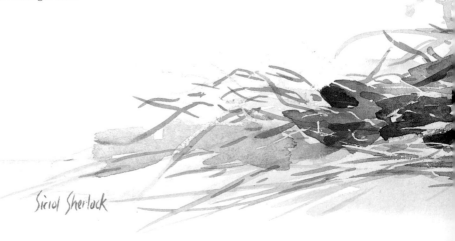

Fig. 33

Wild Primroses
10 x 16 in (25.5 x 40.5 cm), 2 days, brush sizes 8 and 6, plus a ruling pen and old brush

Siriol Sherlock

French ultramarine sap green scarlet lake cadmium yellow pale Winsor yellow Davy's gray

Detailed botanical studies

Although the following paintings were painted more slowly and carefully than the previous 'quick paintings', such as *Apple Blossom* and *Oriental Poppies*, they were painted using the same techniques. However, much more attention has been paid to the fine details such as the tiny stamens in *Rosa cymosa*, and the markings on the petals of the hellebores (see page 58).

It is traditional for botanical illustrators to write the botanical name of a plant on the painting, but this is not advisable unless you have perfected a good script, or it may spoil the picture. Botanical names must, of course, be written and spelt correctly (see Bibliography, page 126).

Rhododendron cinnabarinum

The branch of this beautiful rhododendron (see opposite) was carefully selected from the shrub for its pleasing shape and structure which would make an interesting composition on the paper. A little artistic licence was used to ensure that none of the stems formed strong horizontal or vertical lines, which would distract the viewer's eye from the overall design. With watercolour flower painting, the general rule is always to paint the foreground flowers first, building up with other flowers around and behind them, then painting in the leaves and stems and lastly, the fine details. Usually this means you will be working from light to dark, which is vital as watercolours are translucent and it is

therefore impossible to cover a dark colour with a pale colour. If you put a leaf or a stem in too early and it is in the wrong place, you will not be able to erase it or paint a flower over it.

Rosa cymosa

This painting (overleaf) was commissioned to illustrate an article about this plant in *Curtis's Botanical Magazine* (incorporating the *Kew Magazine*). This is a scientific magazine read by horticultural experts all over the world, so I had to pay particular attention to detail and ensure that the colour and character of the plant was as lifelike as possible and that it was painted exactly life size. This is one of the few occasions when I get out a ruler to take measurements of flower and leaf sizes. Despite the fact that I hoped that the painting fulfilled all that was required scientifically, it was painted using the same techniques shown throughout the book – wet-on-wet, wet-on-dry, softening and so on – though more time and care was taken to get the shapes, colours and details exactly right.

Modern technology has opened up huge possibilities for photographic and computer-generated reproductions but I don't believe this will ever threaten the botanical artist's livelihood: a skilled artist can show much more detail and information in a painting than any photograph. They can also paint the true colours – photographers have great difficulty in reproducing true, natural colours – and, unlike the photographer, the artist can also show the whole thing 'in focus'.

Fig. 34

Rhododendron cinnabarinum
20 x 16 in (51 x 41 cm), 4–5 days, brush sizes 6 and 3

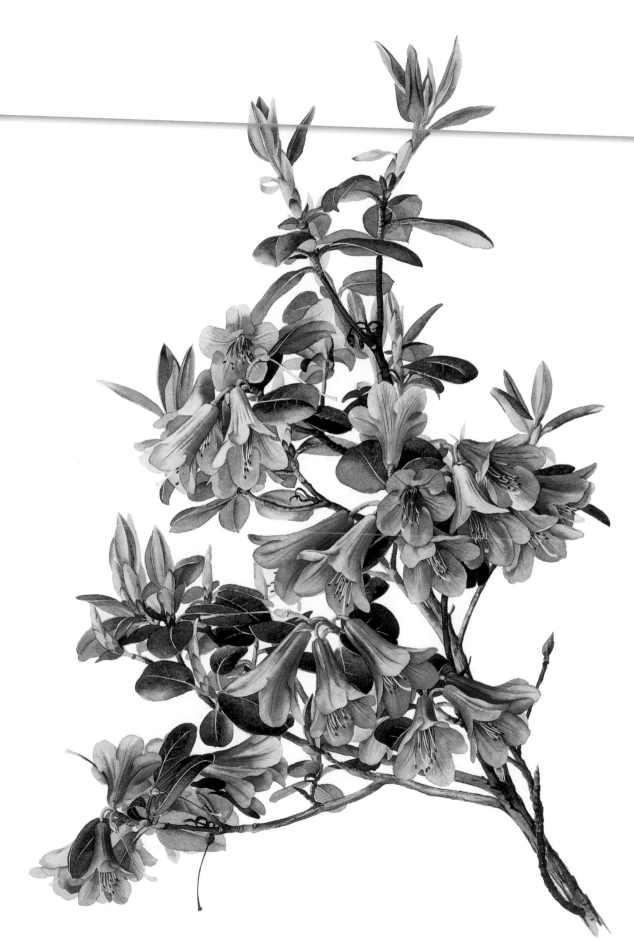

Siriol Sherlock

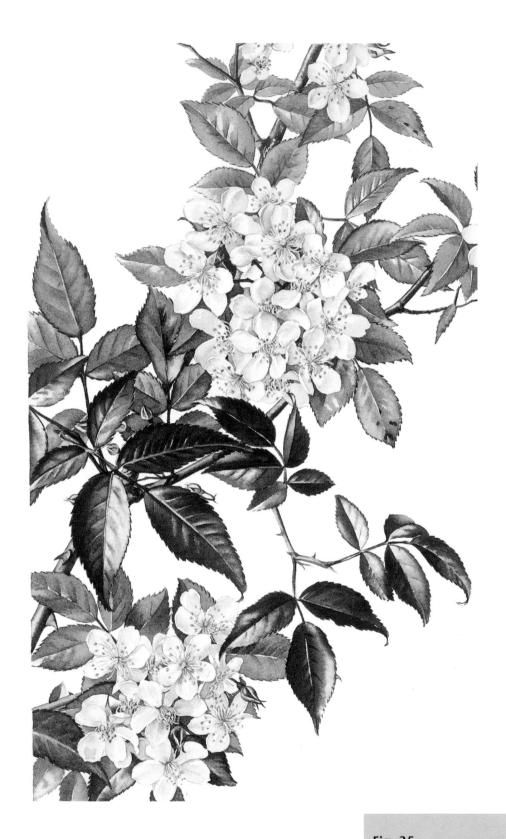

Fig. 35

Rosa cymosa 'Rebecca Rushforth'
8 x 4¾ in (20 x 12 cm), 3 days, brush
sizes 6 and 3

Iris sibirica

This study was also painted slowly and carefully, but the paint still has vitality and it isn't laboured and sterile. The addition of the fine details (stamens, veins and markings on the petals) has turned the painting into a 'botanical study' rather than a 'flower painting'. With single plant studies, as with any painting, you need to consider the composition or 'design' of the whole painting.

The elongated shape of this composition suited the character and shape of this flower. Irises have a rather complicated structure which needs to fit together correctly and the fine markings on the petals needed careful attention.

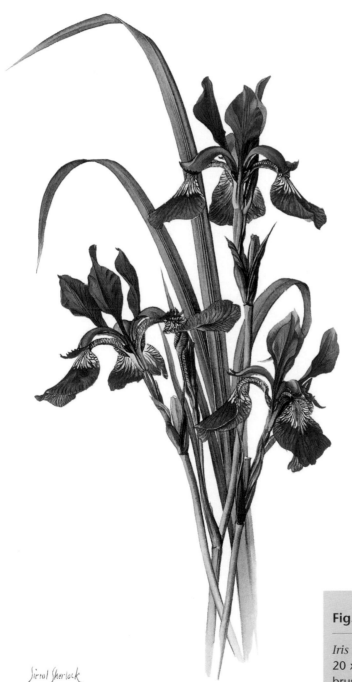

Sirrol Sherlock

Fig. 36

Iris sibirica
20 x 14 in (51 x 35.5 cm), 2 days, brush sizes 6 and 3

Foxgloves

Foxgloves are difficult flowers to paint. Not only do they have complex flower shapes, they also have a complicated structure and intricate markings. Some preliminary pencil drawing is essential to make sure that everything hangs together. A quick field study of spires of foxgloves growing in a shady hedgerow might be an easier option than a botanical study!

In the example opposite the flowers, stem and sepals have been left unfinished to show the early stages of painting, but in reality I would complete each flower, one at a time, working from the top down. It is a good idea to finish each flower as you go rather than paint all of them to one stage and then go back to complete them. If you have to leave the painting for a while (to eat or sleep for example!) then it is not such a problem if the flowers change while you are gone, because you haven't left several unfinished flowers. When painting a detailed study like this, it is advisable to use somewhat smaller brushes than for a 'loose' painting like the *Oriental Poppies* on pages 44–5 where I used brush sizes 10 and 8. Here I used brush sizes 6 and 3 which still hold lots of paint, but are more controllable.

Half-painted Foxglove

Colours
Permanent rose, Winsor violet, Payne's gray, permanent carmine, sap green, French ultramarine, cadmium yellow pale

Method
1 First the plant was quickly and lightly drawn with pencil. It was important to draw in the stem so that the individual flowers would be in the right positions and would hang from it correctly.
2 Starting at the top and working down, the first group of buds was painted with a wash of pale green.
3 Darker details were added.
4 Moving down the stem, more buds were painted.
5 Then, working my way down, I painted the flowers and their sepals, one by one as described in steps 6–13. Gradually, I added sections of stem, making sure they lined up.
6 The outside of each flower was painted first with darker pinks added to a paler wash, wet-on-wet.
7 The inside of each flower was painted next, leaving vague white shapes.
8 More detail and strength was given to the exterior of the flower.
9 Painting the shadow inside the trumpet started to give depth, and the markings inside were strengthened.
10 Final details were added to the inner markings.
11 The outside of the trumpet was strengthened and tidied up.
12 The sepals were painted with a green wash.
13 Darker details were added to the sepals.

Fig. 37

Foxglove (half painted)

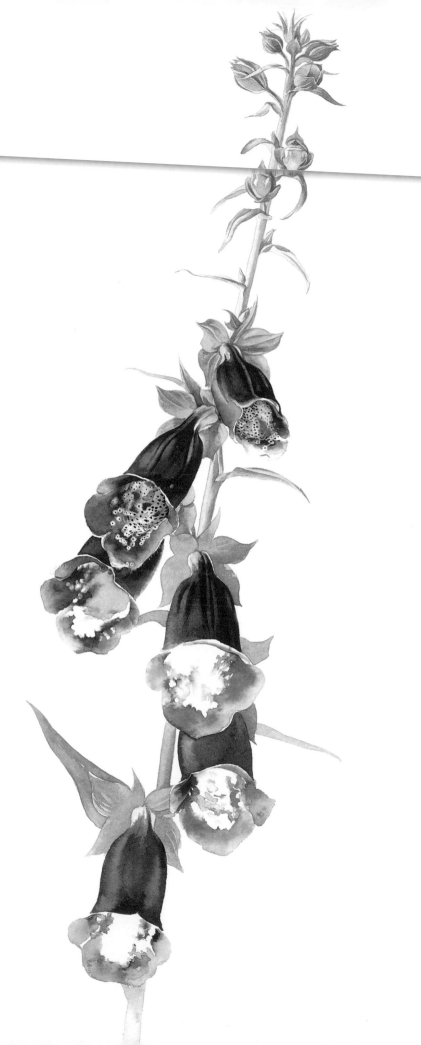

A botanical composition

The painting *Hellebores* (shown opposite) which contains several different flowers of the same species, was more complicated to compose and is also quite detailed. It was therefore quite a difficult painting to construct. When painting compositions involving lots of different plants and flowers in one picture, advance planning and more time and patience are needed to get the best results.

Hellebores

This painting was commissioned as a retirement gift and the flowers were brought to me to be painted. Fortunately the owners of the hellebores were extremely understanding and when some of the flowers wilted before I could paint them, they were happy to bring a few more. Cut hellebore flowers wilt quickly, but the leaves last for a long time, so I made sure I had completed most of the flowers before turning to concentrate on the leaves. I realised later that the white flower had a small extra petal – a freak of nature, as these hellebores normally have five petals. I painted this exactly as I observed it, perhaps the botanical experts would say I should have omitted that petal!

Colours
Lemon yellow, Winsor yellow, permanent rose, permanent carmine, Davy's gray, sap green, French ultramarine, Payne's gray

Method
1 Starting with the white hellebore (Christmas Rose), the main focal flowers were painted first. As with other white or pale-coloured flowers, the outlines of their petals were lightly pencilled in, so that the flower shapes would not be lost when painting in the leaves later on.
2 When painting each flower, the central area, where the stamens would be, was painted with a pale yellow wash and allowed to dry.
3 Then each petal was painted, carefully working the paint around the stamens with tip of the smaller brush. By painting in this way, I was actually forming the petals and the stamens at the same time. However, this was extremely tricky, so some of the stamens were lost and had to be touched up with gouache later. Masking fluid could have been used with a ruling pen to mask the tiny stamens before painting the petals, but this can look a little coarse and for this study it was better to do it the hard way. Remember when painting white flowers that the white paper is the base colour of the petals (see White flowers on page 68).
4 The stems and leaves of each flower were lightly pencilled in for position, so that I could return to paint them when most of the flowers were completed.
5 A combination of wet-on-wet effects, dry brush and dots was used to simulate the wonderful markings on the petals.
6 The main leaves and stems were then painted around the flowers and the strong tonal and colour contrasts immediately threw the flowers to the foreground.
7 The smaller pale green flowers of the *Helleborus foetidus* were added towards the end of the painting and helped to balance the overall design of the composition.

Fig. 38

Hellebores
16 x 12 in (41 x 30 cm), 1 week, brush sizes 10, 6 and 3

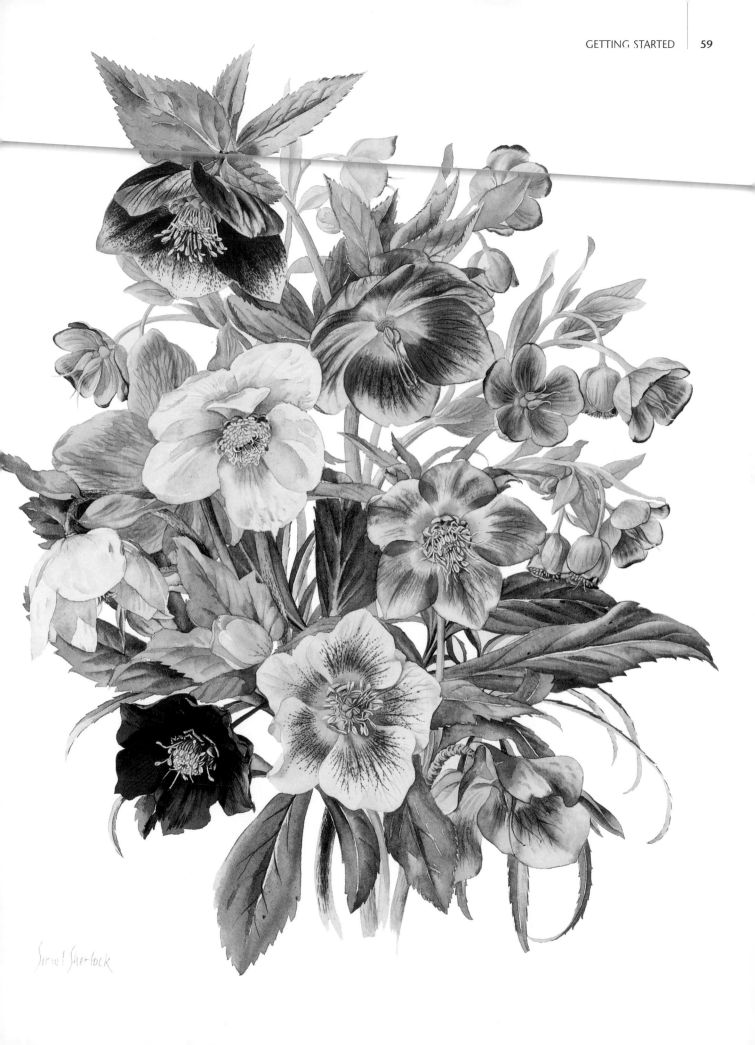

CHAPTER 5

CHALLENGING FLOWERS

Every flower presents a new challenge to the artist, with different problems to be solved. To represent the flowers that you see in front of you with brushes and paint on paper can sometimes be difficult. This chapter should help with some of the problems encountered when painting certain types of flower – for example white flowers, yellow flowers, fiddly little flowers and large flowers. Masking fluid can be a useful tool to help in certain cases. Finding a way to paint the unusual textures of some plants, for example the silkiness of pussy-willow, is another challenge. Tropical plants can be particularly testing. Some of the old favourites, beloved by artists and their buyers, are not necessarily the easiest flowers to paint. Roses, for example, are always popular but can be very difficult.

Roses

Roses are never easy and red ones, which many artists wish to paint, are the most difficult, as they are usually a rich, velvety red which is extremely difficult to achieve in watercolour. It is hard to find a pure, deep crimson or red in watercolour which can really do justice to a red rose. A typical rose also has multiple petals, and it would be much easier for a beginner to start with a single-petalled wild dog rose (see page 62). Another alternative would be to paint the roses in a looser style, like *Summer Roses* on page 66, where it was more important to capture the character of the flowers than to put in every petal.

A Full Blown Rose

The method shown here is one way of painting a rose, although there is no strict formula and my method varies every time! It is very easy to get 'lost' among the petals when painting roses, peonies or similar flowers which have multiple petals. To overcome this, a few pencil marks to indicate the main features of the rose will help to guide you while you are painting it. Do not draw the whole thing, as this would take ages and the petals will certainly have moved by the time you start painting. Brush sizes 10 and 6 were used.

Colours
Winsor yellow, Winsor orange, bright red, French ultramarine

Method
1 The whole shape was painted with a pale peach wash, leaving a few touches of white to act as 'landmarks'.
2 Touches of darker peach were dropped in wet-on-wet.
3 Darker shapes were picked out, forming contrasts against the light edges of other petals. Where a hard edge was not wanted, the paint was softened with a wet brush; this 'softening' is what makes the petals look curled.
4 Gradually, deeper colours were added, painting around the lightest petals.
5 The darkest shadows and central details were added last.
6 Then the leaves were added, in sharp contrast to the flower (see the rose leaves on page 91).

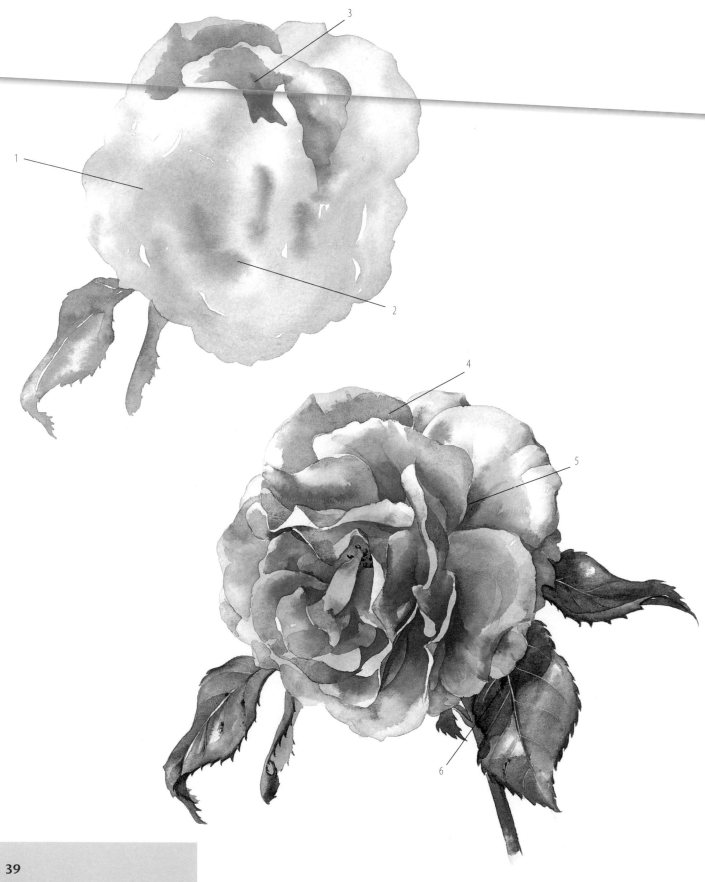

Fig. 39

A Full Blown Rose (stages 1–4; 5–6)

Pink Dog Roses

The petals of a wild dog rose are much less complex and therefore much easier to paint. The flower petals are white in the centre and pink near the edges and a similar effect was required to paint the anemone on page 31, although the paint colour is obviously much paler. When painting the anemone the paper was wetted first then red petals were added; this time the pink petals were painted and water was then added to merge pink into white. These are two ways of achieving the same effect. I used brush sizes 10, 8 and 2 for the two dog roses.

Colours
Winsor yellow, cadmium yellow pale, Winsor orange, scarlet lake, permanent rose, bright red, Winsor blue, cobalt green, French ultramarine

Method
(for two dog roses)
1 The paper was wetted and a dab of pale yellow was dropped in followed by a touch of deeper yellow in the centre. The outer edges of the petals were painted with a pale pink wash and the colour was drawn towards the centre with a clean wet brush. The first touches of shadow were added while it was still damp.
2 More shadows were added to this flower and then softened with a wet brush. The second flower was painted in the same way, the shadows on it forming a sharp contrast against the foreground flower.
3 The central details were painted with the small brush, then touches of darker grey were added between and around the stamens and fine grey lines were painted on the petals. Finally the leaves were painted with a pale wash of Winsor blue (for the sheen) adding stronger greens wet-on-wet (see rose leaves on page 91). Then the darker details were put in, wet-on-dry.

Pink Dog Roses, opposite, was painted outside in strong sunlight (with a sunshade over me). Note how the bright light casts strong grey shadows. The flowers were painted first, then soft background greens were washed in around the flowers, wet-on-wet. Finally the darker greens were added which threw many of the flowers and leaves forward giving the painting depth.

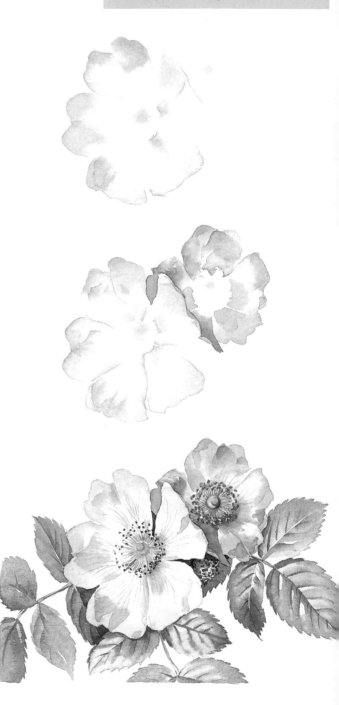

Fig. 40

Pink Dog Roses (stages 1–3)

Fig. 41

Pink Dog Roses
11 x 8 in (28 x 20 cm), 3½ hours, brush sizes 12, 10 and 5

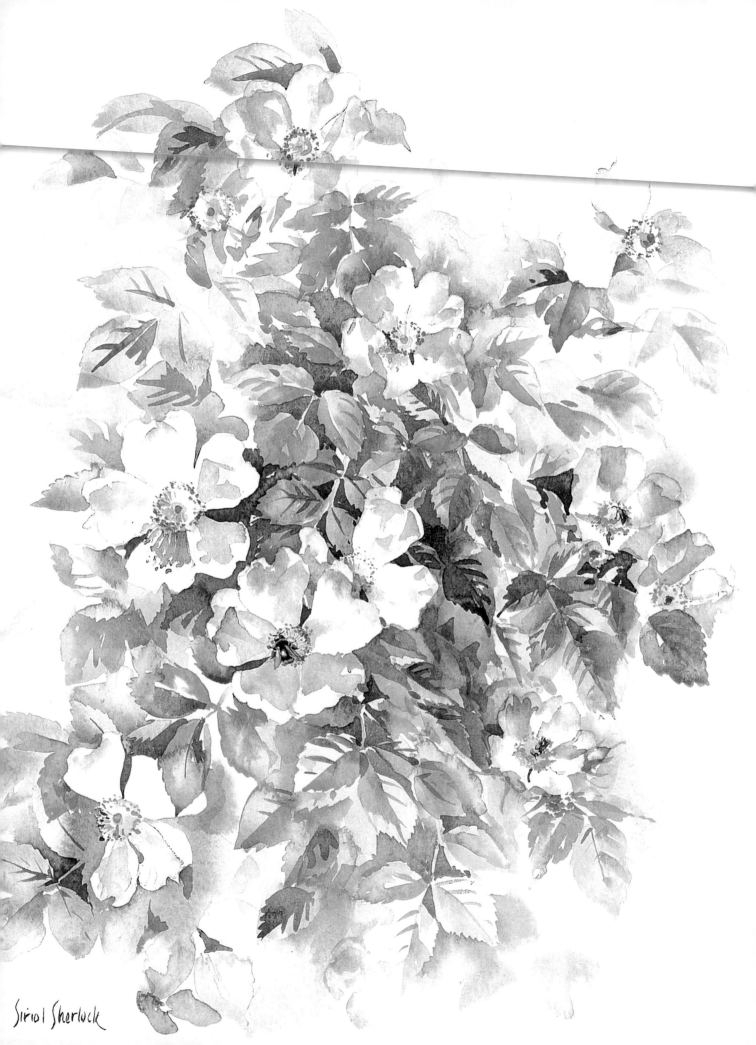

Siriol Sherlock

Old roses

This beautiful, scented, old rose *Fantin Latour* came from the national collection at Mottisfont Abbey Rose Garden, near Romsey in Hampshire. It has hundreds of petals and is probably one of the most difficult flowers I have painted. When I look at something as complicated as this, I sometimes begin to panic and have to tell myself that 'nothing is impossible'. Usually I find that if I think about the task logically and actually begin painting, it all starts to fall into place and my confidence is restored. As with any challenge, confidence is very important. If you are positive and believe in yourself, you can do it. But if your thoughts are negative, and you think you won't be able to cope,

you will probably fail.

It was painted in much the same way as the full-blown rose on page 61. However, it was rather more complicated and it was important to make sure that all the petals looked as though they were growing from the centre of the flowers, and to ensure the overall shape of the roses didn't go adrift.

The painting *Rosa mundi* (of another old rose from Mottisfont) involved a new challenge – how to paint the markings on the petals, as well as defining the individual petals. First I concentrated on getting the markings right, then I put in the shadows and tonal contrasts to separate out the petals.

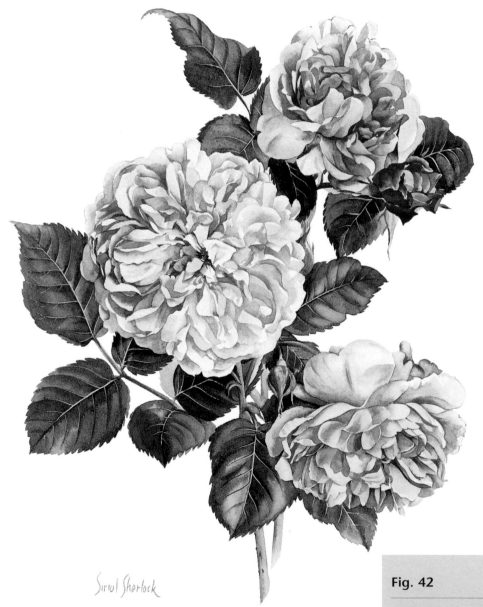

Siriol Sherlock

Fig. 42

Rosa Fantin Latour
17 x 12 in (43 x 30 cm), 5 days,
brush sizes 6 and 3

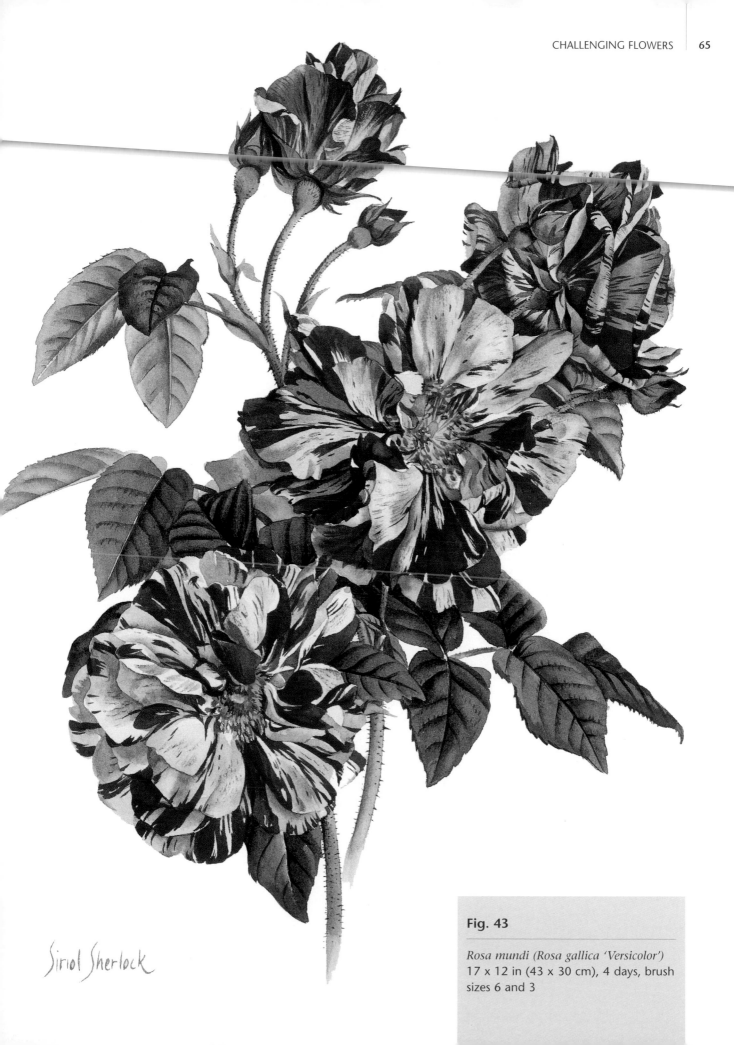

Siriol Sherlock

Fig. 43

Rosa mundi (Rosa gallica 'Versicolor')
17 x 12 in (43 x 30 cm), 4 days, brush
sizes 6 and 3

Summer Roses

This is the most enjoyable way to paint roses – loose and wet, so they really come to life. Strong colour and tonal contrasts give the painting great depth and throw the central roses to the foreground.

Colours
Winsor yellow, Winsor orange, bright red, scarlet lake, Indian red, French ultramarine, sap green

Method
1 The grey shadows on the white roses were painted first, then pencil outlines were quickly sketched in as the roses would soon drop.
2 Pale peach was washed freely over the whole of the central area, avoiding the white flowers; then deeper peaches and greys were added wet-on-dry, to pick out the petals of the peach-coloured roses.
3 All the roses, buds, daisies, Philadelphus and Alstroemeria were completed, pencilling in outlines around any white or pale-coloured flowers to make the next stage easier.

4 The paper was wetted around the flowers and buds and pale yellowy greens were washed in, forming an edge to the white and peach flowers. As this was drying, stronger greens were dropped in, wet-on-wet, around the central flowers, making them stand out.
5 The outline of the jug was pencilled in to get the position and shape right.
6 The strong-coloured leaves and stems were painted, making sure they appeared to go into the jug. The strong contrasts 'lifted' the pale-coloured flowers.
7 The earthenware jug was painted with a very wet wash of the paler colour, and darker colours were dropped in wet-on-wet carefully around the overhanging flowers (see below).
8 Soft yellow Alchemilla and Nigella capsules were added around the edges, to 'balance' the painting and blend into the background.
9 The little pot was painted, then the area around the fallen petals was thoroughly wetted and peachy greys were washed in, wet-on-wet. Then shadows were added under the fallen petals.

Earthenware and pottery jugs

The surface of the large jug looks dull and dry because there are no highlights and the paint is fairly opaque. The shiny glaze on the small pot contrasts against the matt surface of the unglazed pottery.

Method
1 The two jugs were lightly sketched in with pencil.
2 After pencilling in the outlines of the drooping white rose and the daisy, it was not too difficult to paint the large jug around them. The jug was painted with a very wet wash of orange-red (a combination of Indian red, scarlet lake and bright red) with stronger colour (including some French ultramarine) dropped in wet-on-wet. The granulation of the French ultramarine

mixed with the orange-reds simulates the surface texture of the clay jug.
3 Then the small pot was painted: the bottom half was painted first with a watery beige wash, adding darker tones, wet-on-wet.
4 When this was dry, the glazed top half was painted, making sure that the white highlights, down the side and on the rim, were left uncovered by paint.
5 The inside of the pot was painted last, again leaving the white paper highlight, and adding a very dark mixture of Indian red and French ultramarine, wet-on-wet, for the dark inside of the pot.
6 The paper was wetted around the scattered rose petals and watery peachy-greys were washed in freely. Some stronger shadows were added.

Fig. 44

Summer Roses
26 x 21 in (66 x 53 cm), 2½ days, brush sizes 10 and 8

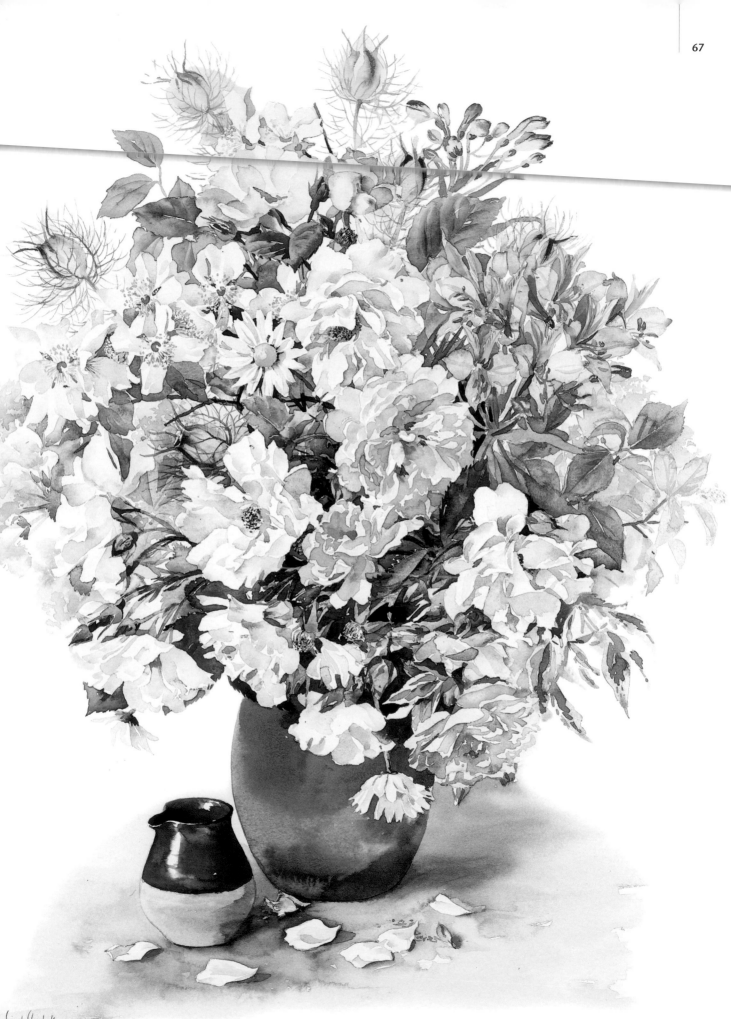

Siriol Sherlock

White flowers

Most boxes of watercolours do not include white paint. This is because you don't need it – your paper is your white paint. You do not paint the white, you only paint the shading and detail on the white. Masking fluid can be used to save small areas of white paper prior to painting and opaque white paint such as gouache is useful for adding small white details like stamens or veins, but there is nothing that matches the brilliance of unadulterated white paper.

Camellia japonica 'Alba simplex'

The soft greys needed for the shadows on the white petals were made from a combination of French ultramarine mixed with different oranges and some Davy's gray.

Method
1 The centre of the flower was wetted first and pale lemon was dropped in and allowed to dry. This gave a hint of yellow.
2 Grey shadows on the petals were put in and softened with a wet brush wherever hard edges were not wanted.
3 The grey was handled carefully in the centre, working around the cylindrical group of stamens and blending it outwards with a wet brush.
4 The edges of the petals were defined with pencil as the painting progressed – this made it easier to add the leaves later.
5 The fine, grey veins were painted with the tip of the smaller brush.
6 The filaments and anthers (parts of the stamen) were touched up with white gouache and white gouache mixed with yellow, respectively.
7 The shiny leaves were painted (see page 95). The tonal contrast of the leaves 'behind' the white flowers shows up the flowers and throws them forward.
8 Finally, a very fine grey line was used to define the edges of some petals before the pencil was erased.

Tips

- Go easy on the grey – if you are not careful, you can easily get carried away and end up with grey flowers and no white paper! The key is to put in less grey than you actually see.
- Keep your water really clean for white flowers.
- Placing white flowers against a darker background will make them look whiter. Against a white background they tend to look grey and you might paint them too dull and grey.
- Don't place leaves behind every white petal in your painting, as this will look unnatural.

Fig. 45

Camellia japonica 'Alba simplex'
24 x 19 in (61 x 48 cm), 2 days, brush sizes 6 and 3

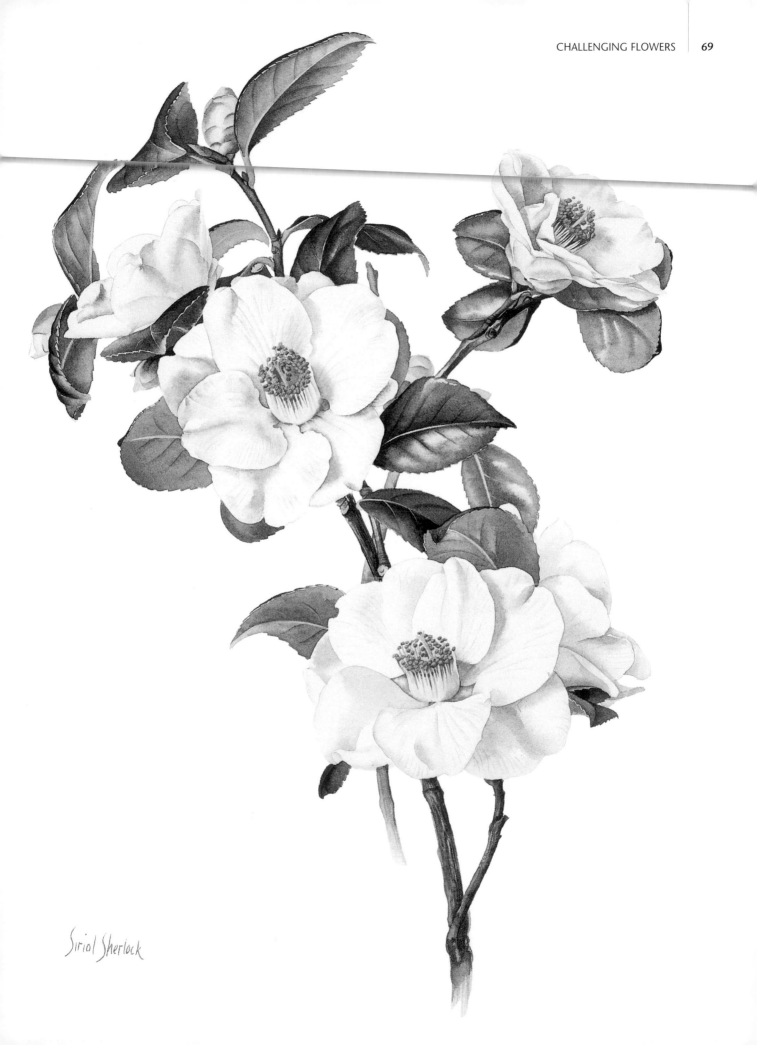

Siriol Sherlock

Snowdrops

Really good, pointed brushes are essential for small, delicate flowers like these snowdrops. I used sizes 6 and 3.

Colours
Davy's gray, French ultramarine, permanent sap green, Winsor yellow

Method
1 Grey was painted with a size 3 brush and softened with a clean wet size 6.
2 Pencil outlines were put in, then the pale green capsules were painted, adding darker green wet-on-wet. Fine stems and sheaths were added with the smaller brush.
3 Final details were added to petals, stems and sheaths.
4 The leaves were painted carefully 'behind' the flowers up to the pencil outlines (the leaves could be drawn in first if you wish). The pale leaf colours were painted first; then the darker greens were added and softened where necessary with a wet brush. Finally some very fine grey lines were painted around the petals before erasing the pencil lines.

Quick study of snowdrops

As with the bluebells on pages 38–9, snowdrops can also be captured in a quick painting.

Colours
Davy's gray, French ultramarine, permanent sap green, Winsor yellow

Method
1 The grey shadows on the flowers were painted first
2 The area around the flowers was wetted and background colour was dropped in.
3 The green capsules and stems were painted.

Tip

Complete the petals of several budded and unopened flowers first, as snowdrops open wide very quickly indoors. The capsules, stems and details can be added later as they don't tend to change.

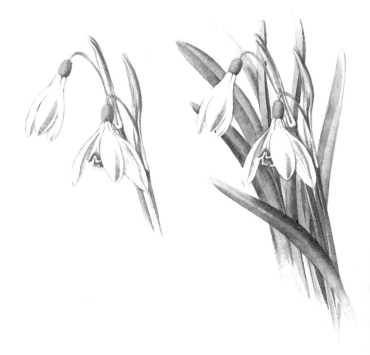

Fig. 46

Snowdrops (stages 1–4)

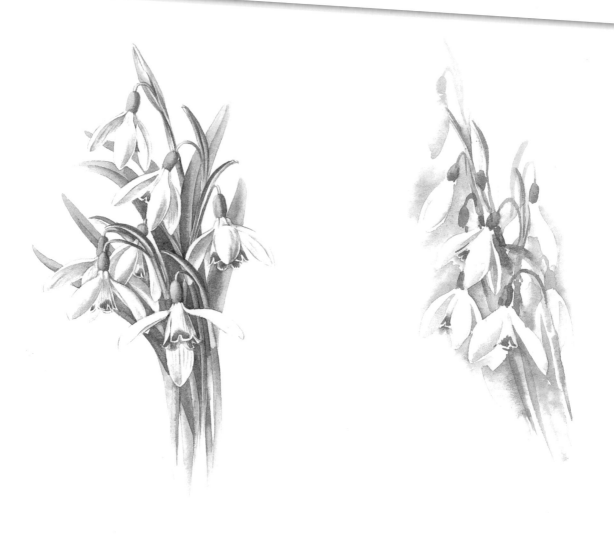

Fig. 47

Detailed snowdrop study
5 x 2 in (12.5 x 5 cm), 4 hours, brush
sizes 6 and 3

Fig. 48

Quick study of snowdrops
5 x 2 in, (12.5 x 5 cm), 30 mins,
brush size 6

Masking fluid

Masking fluid is a liquid-rubber solution which can be applied with a brush, ruling pen, dip pen or matchstick to mask areas of paper and thereby resist paint which is applied after the fluid has dried. One of the drawbacks is that it interrupts the flow of a painting; it also ruins brushes. I never use it for flowers any bigger than daisies (see below), but it can be the perfect solution to a tricky problem (see *Love in the Mist*, page 76).

Daisies

Two Daisy Heads was painted without using masking fluid. This is difficult but gives the flowers a more delicate finish.

Colours
Winsor yellow, Winsor orange, French ultramarine, permanent sap green, crimson lake

Method
1 The yellow centrés were painted first.
2 Then the grey shadows on and between the petals were added.
3 Next the outlines were pencilled in so that the strong greens could be dropped in carefully around the petals, allowing it to merge in to the wet area.
4 The sharp green details were added to the centres.

Daisies was painted with masking fluid. This is an easier way but the flowers do have a coarser look.

Colours
Winsor yellow, Winsor orange, French ultramarine, permanent sap green, crimson lake

Method
1 All the petals and centres of the flowers were painted first with an old size 6 brush, dipped in masking fluid.
2 When it was dry, the paper was wetted all over with a large brush and greens were dropped in, wet-on-wet, freely over the daisies.
3 As the paper was drying, stronger grasses, stems and leaves were added.
4 When everything was dry, the masking fluid was rubbed away with an eraser (fingers will do), leaving stark white flowers.
5 Finally the yellow flower centres and grey shadows on the petals were added.

Fig 49

Two Daisy Heads

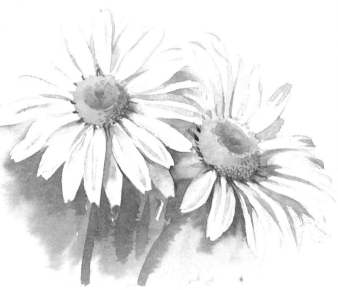

Tips

- Masking fluid ruins brushes, so keep all your old brushes for this purpose.
- To help protect your brush, wet it and coat it with soap before dipping into masking fluid; when you have finished wipe the fluid off the brush – do not rinse it.
- If your masking fluid is too thick, you can mix it with a little water, although if you do so, the soap technique mentioned above will not work.

Fig. 50

Daisies
10 x 12 in (25.5 x 30.5 cm), 2½ hours, brush sizes 10, 12 and an old 6

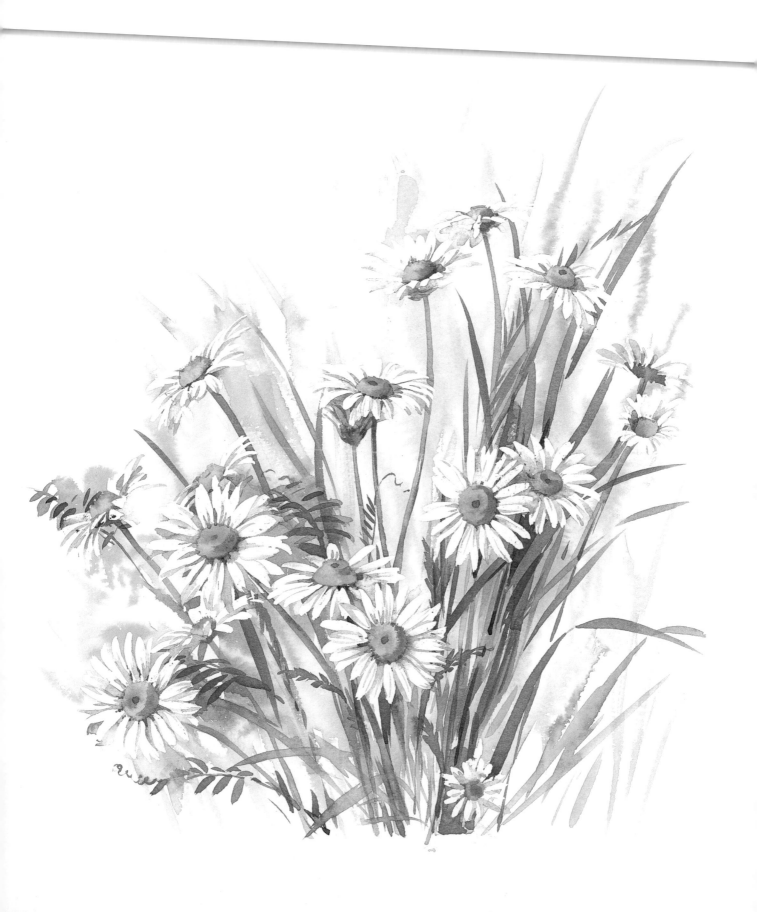

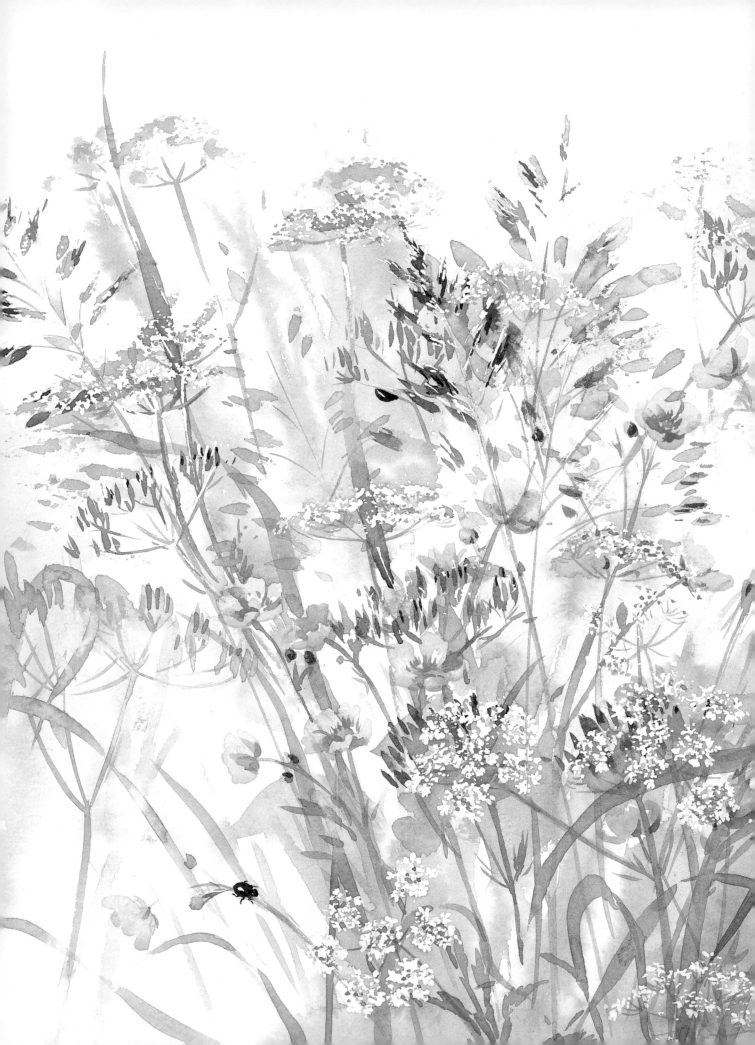

The Meadow

Masking fluid is very useful for saving small areas of white paper. The alternative would be to leave the white until last and use opaque white paint such as gouache, but white paint always looks less vibrant than the sparkling white paper.

Colours
Winsor yellow, cadmium yellow pale, Winsor orange, permanent sap green, crimson lake, white gouache

Method
1 To save the little white areas, dots and splodges of masking fluid were put on with a ruling pen.
2 The yellow buttercups were painted next (remember, light colours should be painted first).
3 Clear water was brushed all over, avoiding the buttercups, and greens were freely added, wet-on-wet, ensuring that plenty of colour was applied over the masked areas.
4 Darker grasses, stems and seed heads were added as the paper dried.
5 When the painting was completely dry, the masking fluid was rubbed away.
6 Where the tiny cow parsley flowers looked a bit sparse, more were added using white gouache.

Winsor yellow cadmium yellow pale Winsor orange permanent sap green crimson lake

Fig. 51

The Meadow
11 x 17 in (28 x 43 cm), 2½ hours, brush sizes 10 and 6, plus a ruling pen

Love in the Mist

Masking fluid was essential for the feathery fronds and the stamens in this painting. The flowers were painted first (see the step-by-step example) then a ruling pen loaded with masking fluid was used on the white paper to mark in some of the fronds. A pale yellowy green, wet-on-wet background was washed in around the flowers. When this was dry, more masking fluid fronds were added to mask streaks of the pale yellowy green. Darker areas of background were then washed in over this masking fluid. When the painting was dry and all the masking fluid had been rubbed away, two tones of fronds were left. Finally, some darker, feathery fronds were added with a fine brush and a ruling pen loaded with green paint.

Tip

If the lines and dots look too sharp or coarse after you have removed the dry masking fluid, soften them in places with a damp brush.

Colours

Winsor yellow, cobalt green, Winsor blue, French ultramarine, Winsor violet, permanent carmine

Method
(for a single flower)

1 The flower centre was wetted and yellow was dropped in. Blue petals were quickly added so that they merged in to the wet centre. When the paint was dry, the stamens were put in with a ruling pen and masking fluid.

2 Darker petals were added and allowed to dry. Then the area around the flower was dampened and a yellowy green wash was dropped in, wet-on-wet. When this was dry, feathery lines of masking fluid were put in with the ruling pen.

3 The dark centre was painted over the masked stamens. Then the background was wetted again before dropping in darker greens, wet-on-wet. Finally, the green fronds and stem were added. When it was completely dry, the masking fluid was rubbed off.

Fig. 52

Love in the Mist studies (stages 1–3)

Fig. 53

Love in the Mist
14 x 10 in (35.5 x 25.5 cm), 1 day, brush sizes 8 and 3, plus a ruling pen

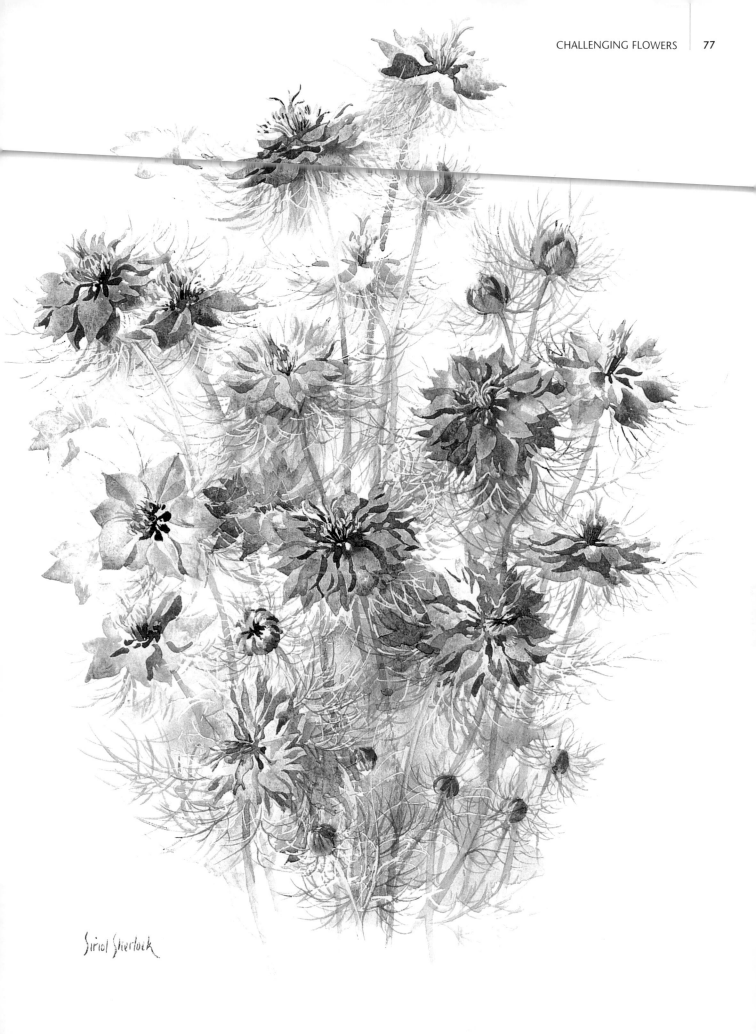

Siriol Sherlock

Yellow flowers

Keeping yellows bright and clean, while at the same time giving the flowers shape and definition is a problem. Yellows are light colours, so how do you paint a dark yellow? Many artists fail badly at this, their daffodils and buttercups, for example, looking dull and sludgy. If you examine the darker shadowy areas of some yellow flowers, they will probably have a tinge of grey, orange, yellow ochre or green; make sure you mix the right shadow colour for your flowers, for there is no standard colour that you can use for all yellow flowers.

The creamy petals of the large narcissus in this study were painted with a pale wash of lemon yellow; I found that a watery Payne's gray and lemon yellow mix proved to be satisfactory as a shadow colour. Payne's gray is very blue and when mixed with stronger yellows it turns too green, so the shadows on the bright yellow daffodils were painted with mixtures of Winsor yellow and Davy's gray or cadmium yellow and Davy's gray (Davy's gray is a very neutral colour). The leaves of the narcissi and daffodils have a blue-grey hue, so I avoided my usual sap green and instead, mixed French ultramarine with the yellows and Payne's gray.

Flower colours:
Payne's gray, lemon yellow, brilliant red, Winsor yellow, Davy's gray, cadmium yellow pale

Leaf colours:
Winsor yellow, French ultramarine, lemon yellow, Payne's gray

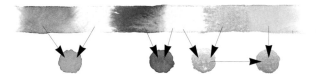

Fig. 54

Daffodils and Narcissi
10 x 11 in (25.5 x 28 cm), 6 hours, brush sizes 10 and 8

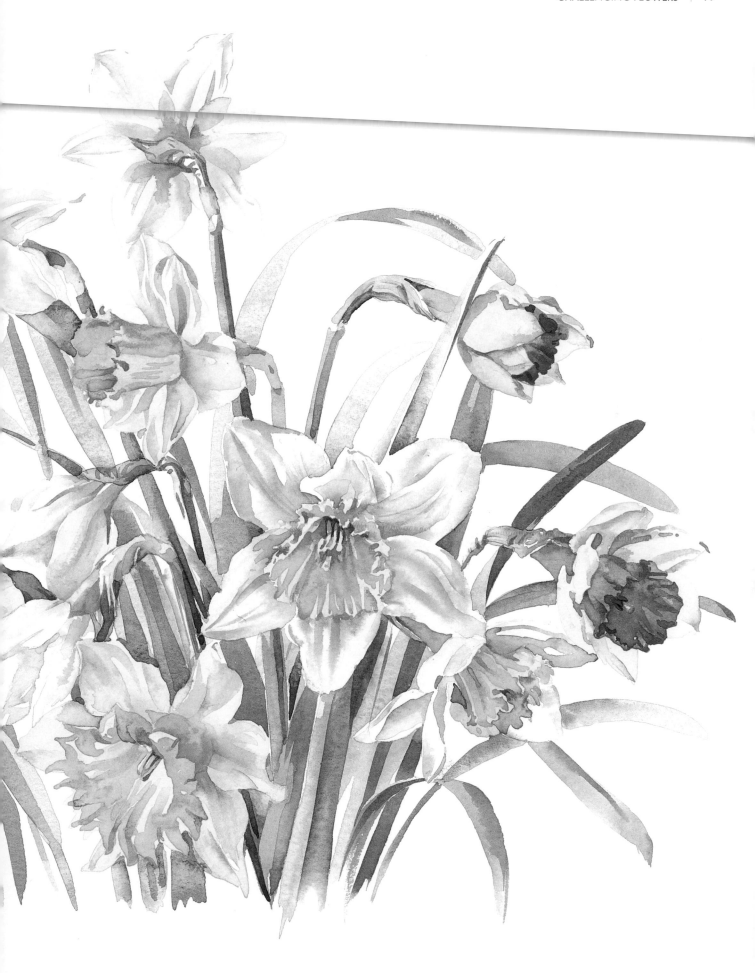

Fiddly little flowers

Fiddly little flowers like those shown here would test the patience of any artist; to paint every tiny flower individually could take ages.

The best way to paint clusters of small flowers – for example the lilac, forget-me-nots, blossom, grape hyacinth, flowering currant and *Ceanothus* illustrated opposite – is to paint the first layer in one joined-up wash (see *Grape Hyacinth*, step 1, below), and then start to pick out little individual flowers with darker colours in the next layer of paint (see *Grape Hyacinth*, step 2).

The little flowers illustrated opposite were painted quite quickly, paying less attention to detail than in the examples demonstrated below. For the *Ceanothus*, blue paint was dropped onto wet paper to form a soft blur before the stronger details were added. Massed tiny

flowers like *Ceanothus*, *Alchemilla mollis* and lilac are really impossible to paint with great detail and accuracy (unless you want to torture yourself!); instead it is much better to paint a vague impression of the whole, picking out details in some areas. See the lilac in *The Blue Jug* on page 112 and the *Alchemilla mollis* in *Summer Roses* on page 67 for examples of this.

Tip

If any tiny white details are lost during painting they can be replaced later with white gouache, although it will not be such a brilliant white.

 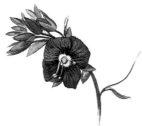

1. The first layer was painted leaving a white centre.

2. Darker petals were added and the hard edge around the white centre was softened with the tip of a damp brush. Then final details were added.

Fig. 55

Speedwell Stages 1–2

1. The first layer was painted, leaving tiny white stars in the flower centres if possible.

2. The darker petals were added and then the final details were put in.

Fig. 56

Forget-me-not Stages 1–2

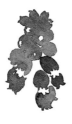 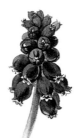

1. The first layer was painted, leaving the tiny white tips where possible.

2. Starting at the top, darker blues were then used to to pick out the little bobbles, softening with the tip of a damp brush where needed. Then the fine details were added.

Fig. 57

Grape Hyacinth Stages 1–2

 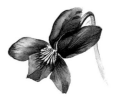

1. Each petal was painted separately here to get definition between them.

2. Darker colours were added, softening where necessary. The tiny details were put in last, with a fine brush.

Fig. 58

Violet Stages 1–2

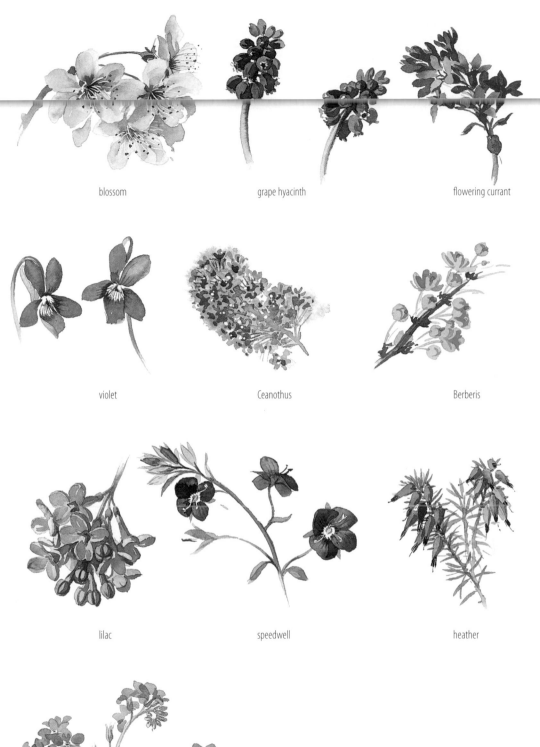

blossom

grape hyacinth

flowering currant

violet

Ceanothus

Berberis

lilac

speedwell

heather

forget-me-not

Fig. 59

Small flowers

Textures

There is often a way to re-create nature's textures without painting every tiny detail. Shown on these pages are several tips I have discovered which can, for example, make pussy willow look silky and old man's beard look fluffy. For more details about creating texture on leaves, see *Hydrangea aspera* on page 92. Brush sizes 6 and 2 were used for all these studies.

Pussy Willow

Colours
French ultramarine, Winsor orange, Winsor yellow, permanent sap green, scarlet lake, white gouache

Method

1 First, grey was dropped onto wet paper to give it a soft blur. When this was dry a streak of beige was painted down the darker side of the twig and immediately a lighter wash was run beside it down the lighter side, drawing the darker colour into the light.

2 The area around the fluffy buds was wetted and a blue-grey background was dropped in to silhouette the silvery-white buds (note that in a complete painting, rather than a study like this, there might be leaves or stems behind the buds). Any hard edges around the buds were softened with a damp brush and fine, feathery, dark grey lines were painted. The sepals were added.

3 The twig and sepals were strengthened and fine, feathery white gouache hairs were added to improve the fluffy, silvery look.

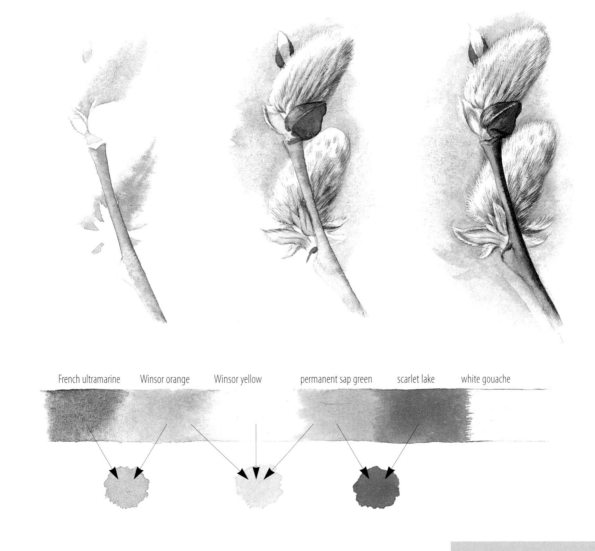

French ultramarine Winsor orange Winsor yellow permanent sap green scarlet lake white gouache

Fig. 60

Pussy Willow (stages 1-3)
Life size

Old Man's Beard

It only took minutes to re-create this old man's beard, using wet-on-wet, dry brush strokes and a fine brush for details.

Joseph's Coat (Pulmonaria)

For this study, as usual, the flowers were painted first, then the leaves and stems. It took some time to paint, as both the flowers and leaves needed careful attention to achieve the texture and hairiness. The light spots on the leaves were 'lifted' (after painting the leaf) with a wet brush and tissue (see lifting colour, page 29).

Fine white gouache hairs were added last with the tip of a fine brush.

Colours
Permanent rose, French ultramarine, crimson lake, permanent sap green, cadmium yellow pale,

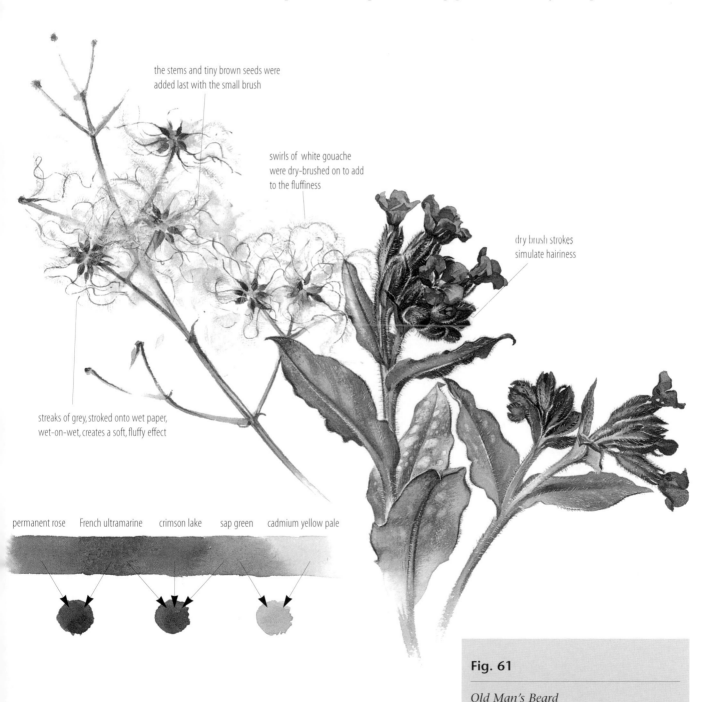

the stems and tiny brown seeds were added last with the small brush

swirls of white gouache were dry-brushed on to add to the fluffiness

dry brush strokes simulate hairiness

streaks of grey, stroked onto wet paper, wet-on-wet, creates a soft, fluffy effect

permanent rose French ultramarine crimson lake sap green cadmium yellow pale

Fig. 61

Old Man's Beard
Joseph's Coat (Pulmonaria)
7 x 7 in (17.5 x 17.5 cm)

Painting large flowers

Large flowers may seem a bit daunting, but in fact they are much easier to paint using the 'wet' watercolour method used throughout the book, than they would be by building up layers of paint with small brushstrokes.

Magnolia

Magnolias have a very distinctive shape, which could go haywire if you paint them completely freehand. A few faint pencil guidelines just before you paint each flower should be enough to guide your paintbrush, but do not draw all the flowers completely before you start painting, or they will have opened up when you go back to paint them. Here the large open flower, which was my focal point, was completed before deciding where to place the other flowers. Always consider the overall composition and remember that the addition of leaves, flowers or buds behind the main flowers can improve the whole to make the picture more attractive and balanced. Do not automatically paint the plant exactly as you see it in front of you; this is one great advantage that the painter has over the photographer.

Colours
Lemon yellow, permanent carmine, Davy's gray, sap green

Method

1 Starting with the open flower, the lightest petals were painted first by wetting the paper and brushing in creams and greys, wet-on-wet.
2 Other petals were added behind and around them, creating sharp tonal contrast to make the lighter petals stand out. The wet-on-wet technique is ideal for that soft blending of pink, cream and grey.
3 The strong pink texture on the backs of the petals was brushed on using the dry brush technique and the effect was softened slightly with a damp brush.
4 The stem and leaves of this flower were lightly pencilled in for position before painting the other flowers.
5 The stems and leaves were painted after all the flowers were completed.

Tips

• When painting large flowers, use really wet washes for each petal, this gives you plenty of time to add colours wet-on-wet and mould the shapes of the petals.
• Use a clean damp brush to mop up and control colour if it spreads too far.
• To produce a good 'dry brush' effect, dip your brush in paint then work off most of the colour by stroking it on scrap paper until it produces the desired effect. The secret lies in having the brush not too wet and not too dry, with the hairs spread apart.

Fig. 62

Magnolia 'Peppermint Stick'
13 x 11 in (33 x 28 cm), 1½ days, brush sizes 8, 6 and 3

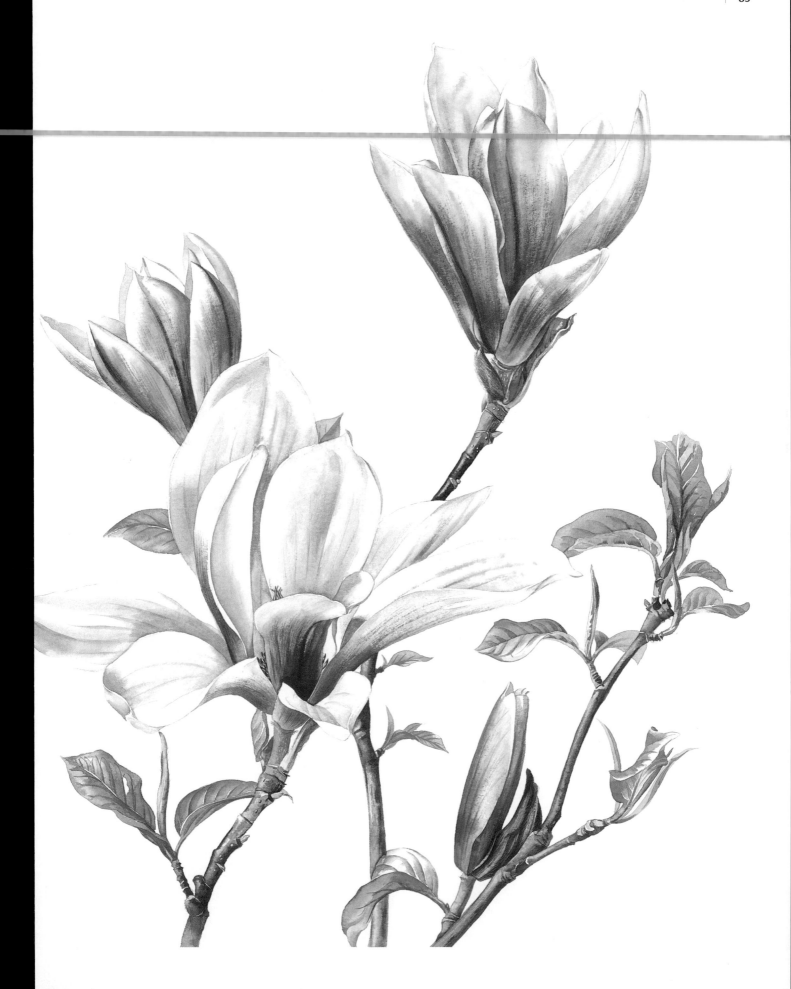

Tropical plants

Tropical plants can be a real challenge and the first problem is where to find them. These exotic plants, overleaf, were painted at a wonderful, tropical rainforest in deepest Berkshire! I was lucky enough to be allowed to paint some of the exotic plants at Wyld Court Rainforest, near Newbury, where they have created a microclimate under glass. Although the *Rosa Fantin-Latour* on page 64 and the *Hydrangea aspera* on page 93 were both very difficult flowers to paint, many tropical plants are even more challenging. To do justice to such exotic plants, many of which have extraordinary shapes and markings, you need to paint them in detail.

The flower detail from the *Passiflora quadrangularis* study, shown opposite, was actually painted from three different specimens. The flowers were too high up to paint 'in situ', so a flower was cut which was then stuck into a block of oasis. The oasis was then anchored on a box just above my eye level so that I could look up into the flower centre. It wilted very quickly and as it took me about three days to complete just one flower, it had to be replaced, which made my job even more difficult.

The starting point was to pencil in the outline. Then I painted the centre and the stripy bits, followed by the outer petals and finally the tips of the little tendrils with white gouache. I then painted the trailing stems, leaves, buds and tendrils from another specimen which was also stuck in oasis.

Most of my paintings are planned in my mind's eye, but the complicated composition of Lowland Tropical Forest Plants was sketched and rubbed out several times before I was happy with the basic structure – and even then it was altered many times as the painting developed. The plants in the painting were growing close by one another at Wyld Court in the 'rainforest'. I sat among them in tropical heat and humidity with my large drawing board and paints, much to the amazement of many parties of schoolchildren who passed by. The white orchids (*Angraecum sesquipedale* and *Phalaenopsis*) were painted first. Then the leaves of the *Angraecum* were painted in behind, carefully working around the long, thin spurs which hang below the white flowers, which were of course the white paper. The huge, overhanging leaf of *Alocasia korthalsii* was painted quite early on, as I wanted it to appear to be in front of the other leaves.

Fig. 63

Passiflora quadrangularis (detail)

Overleaf:

Fig. 64

Passiflora quadrangularis
28 x 19 in (70 x 48 cm), flower size approx 5 in, 1½ weeks, a variety of brush sizes between 10 and 2

Fig. 65

Lowland Tropical Forest Plants
26 x 19 in (66 x 48 cm), three weeks, a variety of brush sizes

CHAPTER 6

FOLIAGE AND FRUITS

Both leaves and fruits are very important parts of a plant; to a botanist who is
trying to identify the plant, they are as important as the flower, or even more so.

Foliage

Badly painted leaves will spoil a flower painting and
although in theory they should be easier to paint than
flowers, many artists have problems when it comes to
leaves. Once the flowers in a painting have been
finished, there is less time pressure on the artist, as cut
foliage usually lives much longer than flowers.

Leaves usually have a smooth or shiny surface, as
opposed to one that is rough or textured. If you paint
using small brushstrokes and build up many layers of
paint, it will be very difficult to create such a smooth
finish. This technique will instead create a streaky,
textured finish which becomes 'muddy', unlike the
smooth surface of a leaf. The answer to this problem lies
in two key points:

• Few layers – by using the wet-on-wet technique you
 can get lots of shape into a leaf in just one layer of
 paint. You shouldn't need more than two layers to
 build up a finished leaf; plus the addition of some final
 details.

• Large brushes – by using really wet washes and fairly
 large brushes, you can paint a whole leaf in one go, not
 little by little, as you would with a small brush which
 holds little paint.

Painting different leaf shapes

Use the shape of the brush to help you create leaf shapes
– don't just put the tip of the brush to the paper, use the
whole of it. Really spread it onto the paper and sweep it
along to complete the leaf shapes.

Grasses

Blades of grass should be the easiest thing in the world
to paint. You cannot paint them tentatively bit by bit,
you must go for it in one stroke of a large, pointed
brush, loaded with paint (a). If this brush stroke isn't

quite right, then you can extend the blade of grass or
widen it, because the paint will still be wet. But if your
paint is too dry and your brush too small, and you
fiddle with the paint, you will add extra layers and end
up with a leaf that is streaky and dull. You really cannot
afford to mess about with watercolour, or you loose that
wonderful translucence. Any flat, linear leaves, for
example those of the iris or narcissi, can be painted just
as easily in the same way.

Ferns

These are also easy if you remember to use the shape of
the brush. A quick way to paint ferns is to lay the brush
tip (loaded with paint) repeatedly on the paper to form
the curved fronds, thereby painting each 'tooth' with
one brush stroke (b).

Lilac leaves

This is a typical 'smooth' leaf. Its shape is what
distinguishes it from any other leaf; it is therefore
important to get this right. The front leaf shown here (c)
has only one layer of paint and yet it already has some
shape and form. It was painted in two halves using the
central vein as a natural division (a whole leaf of this
size is too much to handle in one go), and darker green
was dropped into the light green wash wet-on-wet (d). It
helps to leave some of the veins white, but if you lose
the white, they can be touched up later with gouache.
Stronger greens were overlaid after the first layer was dry
(e) and softened with a damp brush to avoid hard edges
forming. The back leaf (f) could have been completed
with one layer of paint if the wash had been strong
enough first time, but it was actually done in two.

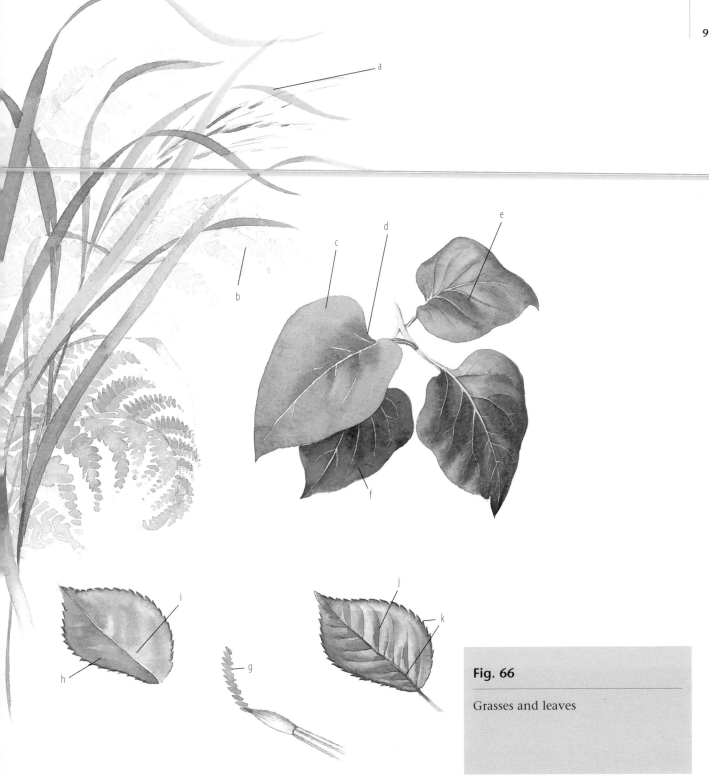

Fig. 66

Grasses and leaves

Rose leaves

The serrated edges of the rose leaves, shown above, were painted by quickly and repeatedly laying the tip of the brush on the paper to make the little points (g), and then flooding paint in to join up the serrations and form half the leaf. Little touches of red were added to the tips of the serrations while the paint was still wet. If you paint the little serrations too slowly or too dryly, and they dry before you join them up to the rest of the leaf (h), they will never quite look part of the leaf. The

paper shining through a thin, translucent first wash makes the leaf appear shiny (i). These leaves, like many others, had distinct bulges between the veins; to create this effect a stroke of green, wet-on-dry, was painted and then softened, so it had a hard edge on one side and softly merged into the 'shine' on the other side (j). Finally the little serrations were neatened up and the veins were added (k).

Leaf colours

The greens of leaves vary enormously. I do not find that a green mixed from blue and yellow is satisfactory as a base colour. Instead I normally use sap green, which is a pure, bright colour, as my base to which touches of yellow, orange, blue, Payne's gray or red are added accordingly, to get the exact hue of each leaf.

Textured or hairy leaves

This *Hydrangea aspera* was a great challenge. Not only did it have mounds of tiny fluffy flowers but also dull, velvety leaves which, on close examination, were covered with a sheen of tiny white hairs. I had to experiment to find suitable colours and a way of simulating the texture. Brush sizes 6 and 2 were used.

Colours
Permanent rose, crimson lake, Winsor violet, French ultramarine oxide of chromium, Payne's gray, white gouache.

Method
1 First, little dots of masking fluid were used to 'save' white paper.
2 Soft pinky mauves were dropped onto wet paper to create a blur.
3 The larger, pink flowers were painted.
4 More dots of masking fluid were added to mask the tiny pinky mauve flowers. Then the little red buds, stems and darker shapes were painted over the masked areas.
5 Details were added to the flowers.
6 The leaves were painted carefully around the flowers using oxide of chromium – a rather chalky, dull green which was perfect for the job.
7 The undersides of the leaves were painted first with a very pale, grey-green wash (remember, pale colours first) then the darker topside was painted using a mixture of Payne's gray and oxide of chromium.
8 Dry brushstrokes of white gouache simulated the velvety sheen.
9 Some fine, white gouache hairs were added with the fine point of the smaller brush.
10 Fine, dark details were added and more tiny white

Fig. 67

Hydrangea aspera
18 x 15 in (45.5 x 38 cm), 3 days,
brush sizes 6 and 2

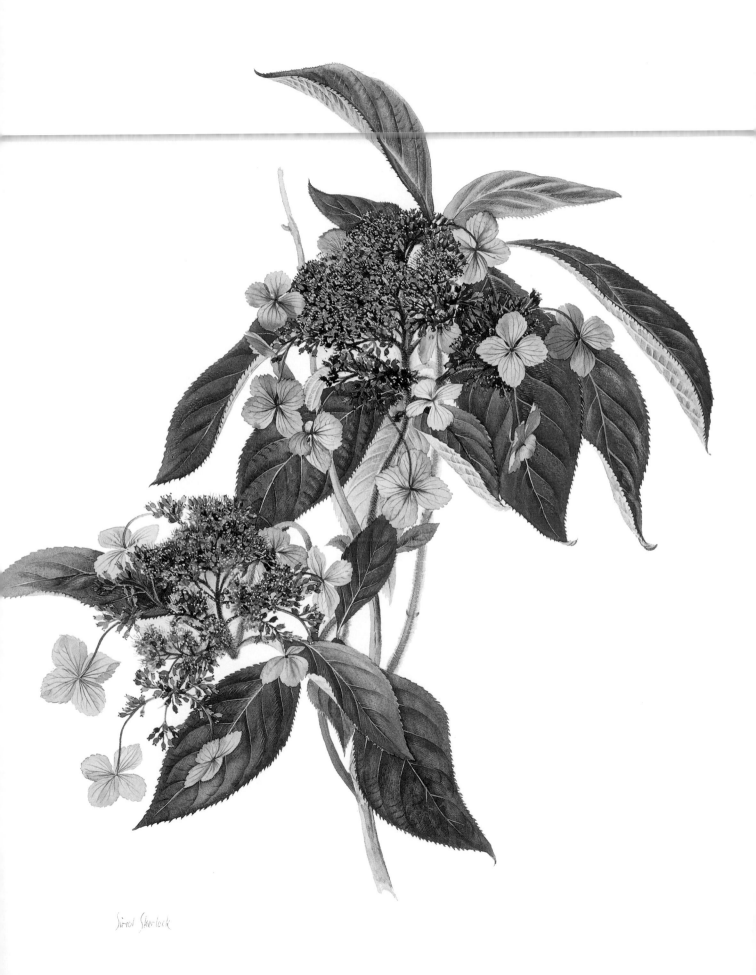

Simon Sherlock

Variegated and shiny leaves

With a variegated leaf like this ivy, you need to create 'pattern' on the surface of the leaf by varying the colours as well as giving it shape and form by varying the tones. This leaf is split into natural sections by the veins, so you can work on one section at a time, getting contrasts of colour and tone between the sections.

Variegated ivy leaf

Method

1 Each section was painted with a watery lemon yellow wash and a combination of greens (mostly sap green mixed with some French ultramarine) were dropped in wet-on-wet (a). If either the lemon wash or the green that you drop in is too wet, green will flood the whole section and you will loose all the cream areas. With experience, you learn to control the paint and know how wet to make it. A touch of French ultramarine gives a bluish sheen (b).

2 Stronger greens were added and softened where necessary with a wet brush (c). The back leaf was washed in with lemon, and greens were dropped in carefully around the edge of the dry, front leaf, forming a sharp contrast against it (d), blending into the lemony wash behind (e). Darker greens were added as it dried. The veins were neatened up with gouache (f).

Ivy leaf

The shine on every leaf is different. This ivy leaf was a dark, bottle green and the shine was almost white with a hint of blue. On a very glossy leaf or berry the shine would be pure white. The shiny sections were painted with a clear wash with a hint of French ultramarine (a), and a sap green and Payne's gray mix was dropped in around the edges of the sections (b) and guided with a clean, wet brush. On the darker sections a very strong, but wet, dark green was dropped into a lighter green wash in one layer (c).

Fig. 68

Variegated leaves

Fig. 69

Ivy leaf

Holly leaf

Like the serrations on the rose leaf (see page 91), the points on this holly leaf must be painted 'as one' with each half of the leaf (a). A clear wash was laid down along the centre of the leaf and green was painted up to the tips, blending into the water wet-on-wet (b) and adding darker green around the edges. The slight bulges between the veins were added, wet-on-dry, as for the rose leaf (c). Note the fine white highlight around the edges (d), which is an important feature of a holly leaf.

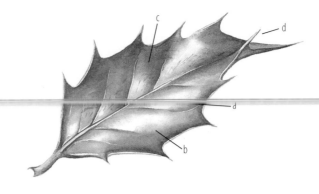
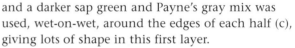

Tip

- Try to paint over dark colours as little as possible – strong paint is easily disturbed and can end up looking very untidy if you mess it about.
- If the colour you use is strong enough to start with, you will not have to use lots of layers to build up the depth of colour.

Fig. 70

Holly leaf

Camellia leaf

As this camellia leaf was extremely glossy, it was important to leave some of the white paper showing to give it real shine.

Method

1 A clear wash was put down, leaving the shiniest areas dry, so that no paint would run in to them (a). A hint of French ultramarine was dropped in wet-on-wet (b),

and a darker sap green and Payne's gray mix was used, wet-on-wet, around the edges of each half (c), giving lots of shape in this first layer.

2 The bulges between the veins were defined, as for the rose leaf, using a very strong Payne's gray and sap green mix which was softened into the shine with a clean wet brush (d). Finally, fine dark green and white veins were added.

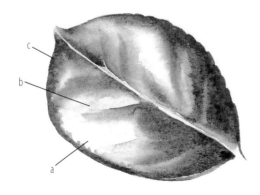

Fig. 71

Camellia leaf (stages 1 and 2)

Autumn leaves

The colours of autumn leaves are incredibly rich and varied. Pure, bright colours are as vital here as they are when painting flowers.

Colours
Sap green, cadmium yellow pale, Winsor orange, bright red, scarlet lake, crimson lake

Maple leaf

Method
1 By painting each triangular section individually, using the main veins as dividing lines, it was possible to get lots of colour variation into the first layer of paint (a), dropping colour into colour, wet-on-wet. If the whole leaf had been attempted in one go, it would have dried out before enough colours had been added. The second layer of paint, added wet-on-dry, began to give the leaf form (b).
2 The colours were strengthened in the last layer, using a dry brush technique (c) and dots to create the pattern on the leaf (d).

Tip

The area indicated (e) was overworked by adding and blending in more layers of paint as it was drying. This has 'muddied' and spoilt the lovely translucent paint of the first stage. I continued to try and get it right while it was drying out – this is always a mistake – it is much better to leave it alone to dry completely and then add a new layer of paint which will not disturb the underneath layer so much.

Fig. 72

Maple leaf (stages 1–2)

Oak leaf

As with the maple leaf, life was made easier here by painting the leaf in sections, so that I could concentrate on one section at a time. This little example (a) shows how the leaf was painted in sections which were naturally divided by the veins.

Red oak leaf

This is a good example of using the translucency of watercolour to its best advantage. The white paper shining through almost clear washes, gives a sheen to the leaf (a).

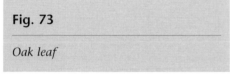
Fig. 73

Oak leaf

Fig. 74

Red oak leaf

Bramble

An Indian red and Payne's gray mix was used for the dark rusty red of this leaf. Much of the texture in the leaf was achieved in the first layer by adding quite strong reds to yellowy green washes, wet-on-wet, giving it a grainy look (a). Darker details and dry brush work gave it more texture (b).

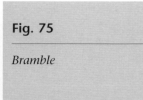
Fig. 75

Bramble

Fruits

Like autumn leaves and flowers, the fruits of a plant are usually very colourful, so it is vital to use pure, bright colours. Fruits bear the ripe seeds of a plant and they vary enormously from berries and nuts, for example, to large fruits such as apples.

Adding dimension

When painting fruits, which are usually rounded in shape, one of the biggest challenges is to make them look round, in other words, to give them dimension.

Three apples

Colours
Winsor yellow, permanent sap green, Winsor orange, bright red, scarlet lake, permanent carmine, bright red, French ultramarine

Method
1 A watery, yellow-green wash was painted and darker colours were stroked in wet-on-wet. Already the apple began to look three-dimensional.
2 As it was drying, stronger colours were brushed in and softened where necessary with a wet brush.
3 When it was dry, dark reds and greens were brushed on and softened with a damp brush.
4 The finished painting shows how more streaks and dry brush strokes simulate the texture and markings and the dark hollow of the stalk adds dimension. The rose hips in the foreground and the old man's beard in the background give the painting more depth, stretching the distance from front to back. Dark shadows under the apples really lift them off the page.

1.

2.

3.

This shows the painting of the left-hand apple in the finished picture with its upturned stalk through steps 1, 2 and 3.

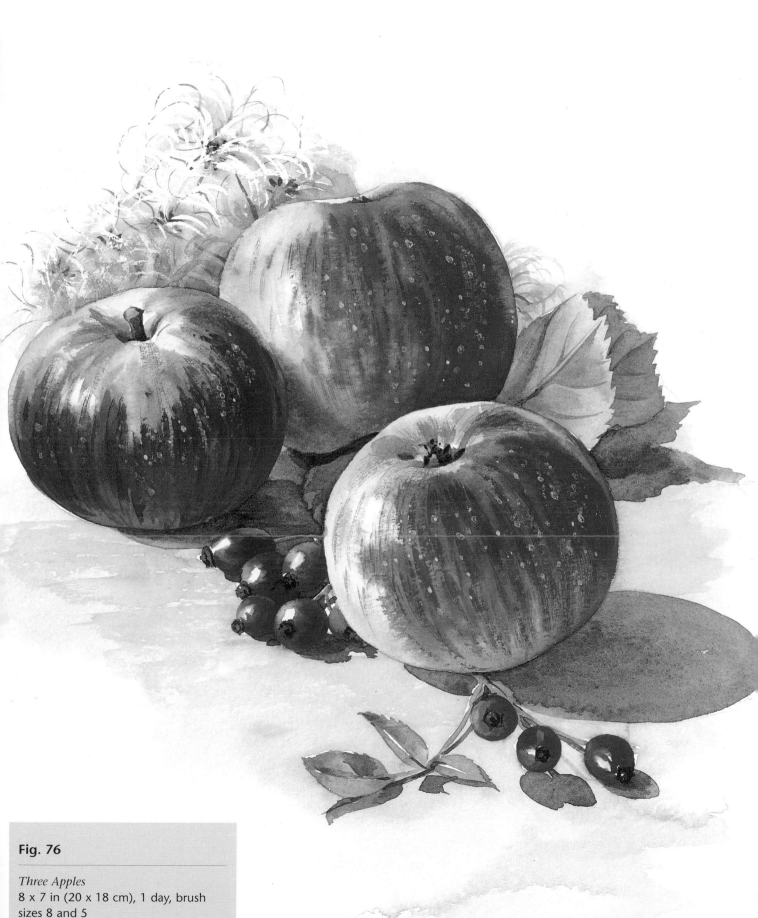

Fig. 76

Three Apples
8 x 7 in (20 x 18 cm), 1 day, brush
sizes 8 and 5

Nuts and berries

Many fruits and berries, such as plums, damsons and sloes, have a bluish-white bloom on their surface. This can fairly easily be created with paint, (see *Sloe berries*, below, and *Plums*, opposite). Other berries are shiny and have sparkling white highlights like the blackberry or a softer shine like the rose hips; even the nuts opposite have a highlight. Creating that highlight is vital, otherwise the fruit will look flat and lifeless.

Nuts and seedpods provide plenty of inspiration to keep you occupied in the winter months.

Rose hips

As with *Three Apples* (on page 97) the wet-on-wet technique used in the first layer of paint (a) gives the berry shape and form immediately and there is very little more to be added to complete the berry.

Blackberries

It is important to leave the little highlights of white paper from the very start. Use the tip of a fairly small brush (size 3 would be suitable) to paint the first stage as shown (b). This is not easy, but if you lose those highlights and have to add them later with white gouache they will not sparkle in the same way. Of course, masking fluid could be used, but your highlights may end up in the wrong positions. Next pick out the individual bobbles with darker colour (strong Payne's gray is good), softening where necessary with a small damp brush.

Sloe berries

A touch of Winsor Blue (green shade) in the first wash (c) was perfect for the colour of these sloe berries; French ultramarine and Payne's gray were also used. When painting small berries, such as elderberries, as with painting small clusters of flowers (see Fiddly little flowers, page 80), several berries can be painted together with one layer of paint and then, in the second layer, the individual berries are separated out by working into it with a small brush.

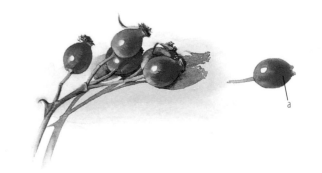

Fig. 77

Rose hips

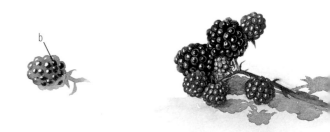

Fig. 78

Blackberries

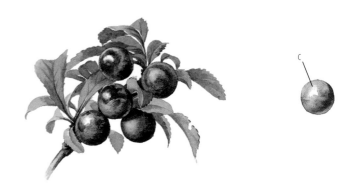

Fig. 79

Sloe berries

Plums

Again, the white highlight had to be saved from the start (d) and a touch of blue in the first wash (e) helps to create the effect of the bloom on the surface.

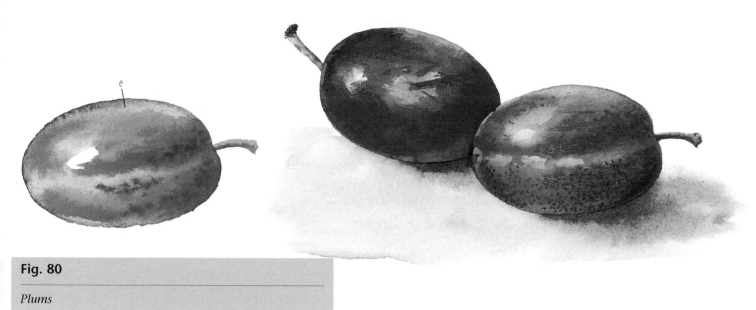

Fig. 80

Plums

Cobnuts

These nuts have a soft sheen and this effect is created by allowing the white paper to show through the translucent wash.

Colours
Permanent sap green, Winsor yellow, Winsor orange, Indian red, French ultramarine

Fig. 81

Cobnuts

Conkers

Colours
Winsor yellow, permanent sap green, French ultramarine, Winsor orange, scarlet lake, crimson lake, Payne's gray

Method
1 The white pith was created first, leaving the paper colour for the whitest parts.
2 The pale green spiky shell was painted next.
3 Then the conkers were painted with a bright orange-red wash, leaving a soft white highlight and adding darker reds and browns, wet-on-wet.
4 The paper was wetted all around the conkers and soft colour was washed in.
5 The blue-grey shadows were painted wet-on-dry with a very wet wash.

Fig. 82

Conkers

Acorns

Method

1 Leaving a white highlight, the tips were painted with a sap green and Winsor yellow mix which was blended into clear water. Orangey browns were quickly added wet-on-wet.
2 The dull, pale green cups were painted and darker details were added wet-on-dry.
3 Darker browns were added to the shiny acorns, softening with a damp brush.

Chinese lantern

Colours

Cadmium yellow pale, bright red, scarlet lake, crimson lake, Payne's gray

Method

1 Working around the holed area, the outer shell was painted with a pale orange wash, adding darker oranges wet-on-wet.
2 The holed area was painted carefully with tiny dark orange shapes, leaving fine skeleton lines of white paper. These fine lines could have been masked previously with a ruling pen and masking fluid.
3 The stalk and sharp details were added next, finishing with the shadow underneath.

Fig. 83

Acorns

Fig. 84

Chinese lantern

FLOWERS IN CONTEXT

Painting flowers in a particular context, for example with vases, backgrounds and in still life compositions, can be a lot easier than painting plant studies. There isn't usually the need to put in every detail, although you could, of course, if you so wished. However, there may be other difficulties: painting pots and jars for example, or putting in backgrounds. But if you have learnt to handle paint, brushes and water when painting flowers, then in theory, there is no reason why you cannot paint a glass jar – you are still painting what you see in front of you.

Flowers in a vase

When painting flowers in a vase, the simplest way is to arrange the flowers and then paint them very much as the arrangement stands in front of you, using a little artistic license to add a few extras around the periphery to make the composition look balanced. Take time to position the flowers carefully – you can't just dump them in a vase and expect them to look beautiful, although, on occasions, this has been known to work! If the arrangement looks pleasing to the eye, it should look pleasing on paper.

Bluebells and Buttercups

I loved the combination of these white, yellow and blue wild flowers in *Bluebells and Buttercups*. They were arranged to look attractive and form a good overall shape, with the white narcissi positioned in front of the darker colours so they would show up. The arrangement was painted exactly as it stood and a few extra flowers and leaves were added at the end to 'balance' the picture. The light shining through the vase cast a strong blue shadow, giving the impression that the vase is standing on something, not just floating in mid air.

Colours
Bright red, French ultramarine, Winsor violet, Payne's grey, Winsor yellow, cadmium yellow pale, sap green, white gouache

Method
1 Starting with the light colours, I began with the white narcissi, using the paper colour as white.

2 Then the buttercups were added.
3 The cow parsley was put in with a ruling pen and masking fluid.
4 The bluebells were painted and the vase was sketched.
5 The stems and leaves were painted, taking care to ensure that they appeared to sprout from the top of the vase.
6 Shadowy greys and greens were washed in over the masking fluid, so that the little white flowers of the cow parsley would stand out.
7 The blue glass vase was then painted (see below).
8 Finally, the masking fluid was rubbed away and the cow parsley was touched up with white gouache.

Blue glass vase

The extremely translucent paint and the bright window reflection are what make this vase look glassy.

Method
1 The outline was sketched in lightly with pencil. Water was washed all over the vase up to the pencil outline, leaving dry patches for the white highlights.
2 Pale blues were quickly washed in wet-on-wet, followed immediately by deeper blues and purples – sweeping the brush right around the curved sides and bottom of the vase, so that it formed a nice strong edge of blue which blended softly into the wet area.
3 Strong colour formed a sharp edge around the dry white area to make the highlight stand out.
4 As the paint was drying, green stems were added.
5 Touches of strong contrast were added, wet-on-dry, to the stems, waterline and the reflection of the windows.
6 The bluish shadow was stroked onto wet paper.

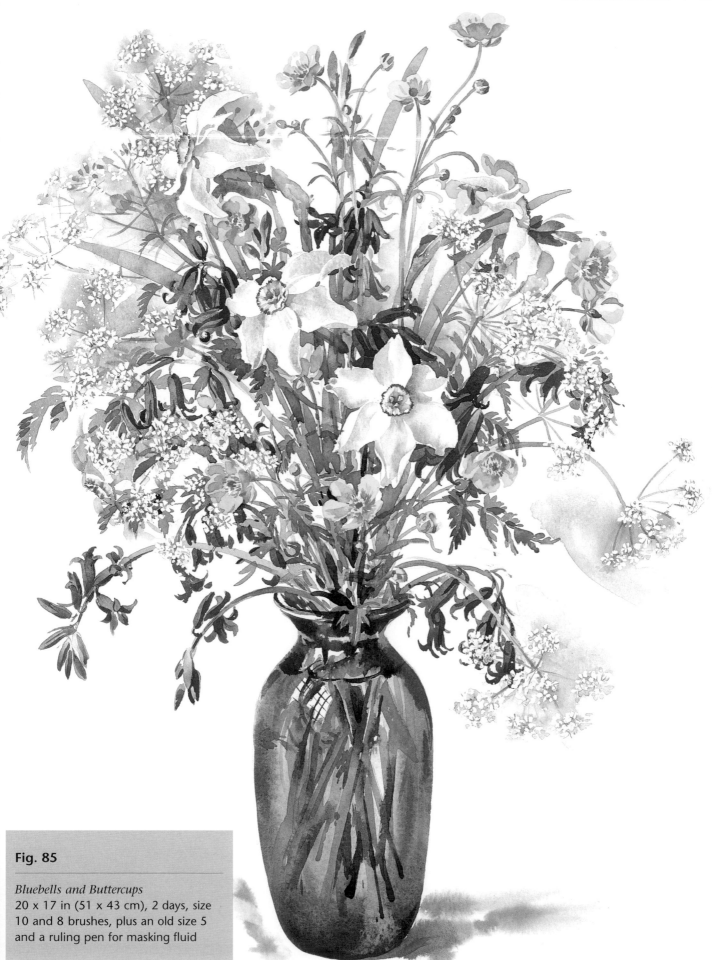

Fig. 85

Bluebells and Buttercups
20 x 17 in (51 x 43 cm), 2 days, size
10 and 8 brushes, plus an old size 5
and a ruling pen for masking fluid

These stages 1-4 show the development of a section of *Bluebells and Buttercups* :

Method

1 A touch of pale yellow was washed in for the narcissi centres. Shadows on the narcissi were painted with a watery French ultramarine and bright red wash, softening with a wet brush. The bright red edges of the central 'cups' were painted with a fine brush, drawing the colour in to the centre with the tip of a wet brush. Then the yellow buttercups were painted.

2 A light pencil outline was drawn in around the white narcissi petals. More detail was added to the buttercups. Masking fluid was applied with a ruling pen to save little white dots for the cow parsley and the bluebells were painted.

stage 1

stage 2

Fig. 86

Bluebells and Buttercups
(details; stages 1–4)

3 More detail was added to the bluebells. The stems and leaves were painted around the narcissi, bluebells and buttercups, making sure there was some colour over the masked areas.

4 The final touches were added: the dark centres of the narcissi and buttercups, and the darker stems and leaves. A shadowy blue-grey was washed into the background. When the painting was dry, the masking fluid was rubbed away and a few more tiny white flowers were added with white gouache.

stage 3

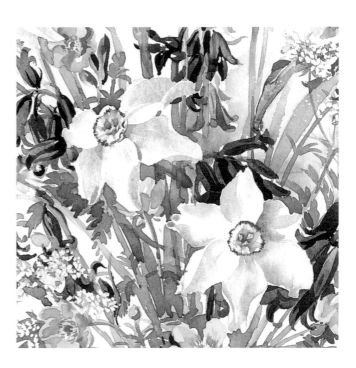

stage 4

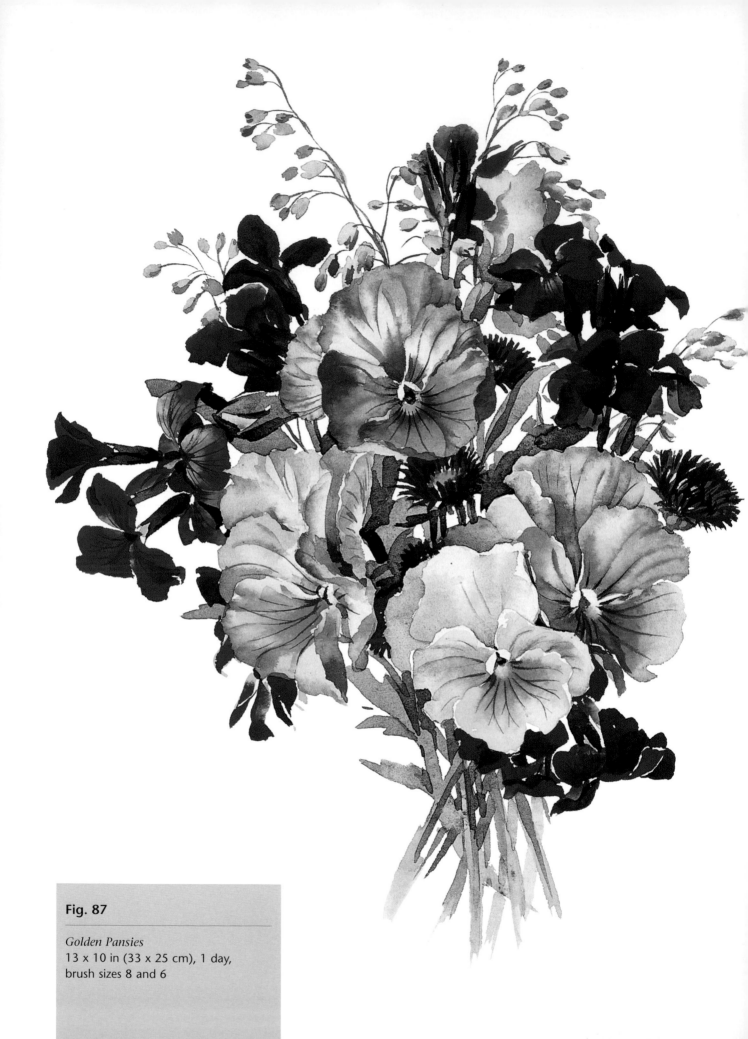

Fig. 87

Golden Pansies
13 x 10 in (33 x 25 cm), 1 day,
brush sizes 8 and 6

A bouquet

The flowers in *Golden Pansies* made an attractive posy. It was painted fairly quickly without going into the finer details. The flowers were placed in a glass vase, so that I could vaguely see the stems through it. With this style of painting, stems fading away at the ends seem to look better than those that are neatly 'chopped'.

Colours
Winsor yellow, bright red, scarlet lake, crimson lake, French ultramarine, sap green

Method
1 Starting with the pale pansy in the foreground, the pansies were painted, one by one, using very wet washes and adding colours on to the paper, wet-on-wet.
2 For each pansy the lower petal was painted first and allowed to dry before painting the two side petals. Thus there was a sharp contrast of colour and tone separating the petals. The top petal was then painted, dropping strong colour into the 'V' shape, wet-on-wet.
3 Next the wallflowers and daisies were painted using strong but still very wet colour.
4 Pale green leaves and stems were put in, painting rather carefully around the edges of the pansy petals, then the dark greens were added. This strong tonal contrast threw the pansies to the foreground.
5 Finally, the little sprays of pale pink *Heuchera* were added, loosely, in the background.

China, glass and pottery containers

When painting vases of flowers, I find it best to concentrate on the flowers first, as they are the most important part of the composition and at that stage I lightly sketch in the container with pencil, so that I know its position in relation to the flowers. After the flowers are completed, I then turn my attention to the vase that they are sitting in.

For painting earthenware and pottery containers, see *Summer Roses* on page 66. For instructions on painting a blue glass vase, see *Bluebells and Buttercups* on page 104 and instructions for a blue china jug can be found on page 112. In *Field Poppies* on page 21, pale transparent washes make the jar look clear but it is the strong tonal contrasts of the stems behind the glass that make it look glassy. Observe any glass container holding water, you will see strong colours, and not wishy-washy colour as you might expect. Note the vital 'white paper' highlights – these could be saved with masking fluid before painting the jar.

Garden pots

I sat in the garden with my large board propped against the garden table to paint *Pots of Blue and Gold*. The composition of this painting is a little worrying as it looks as if the pot in the foreground may fall off the step to the right; lightening the dark shadow (bottom right) would help, but it is difficult to wash out watercolour and you risk spoiling the painting. Note how the white highlight on the blue rim of the terracotta pot makes the glaze look shiny.

Fig. 88

Pots of Blue and Gold
26 x 19 in (66 x 48 cm),
2 days, brush sizes 10 and 8

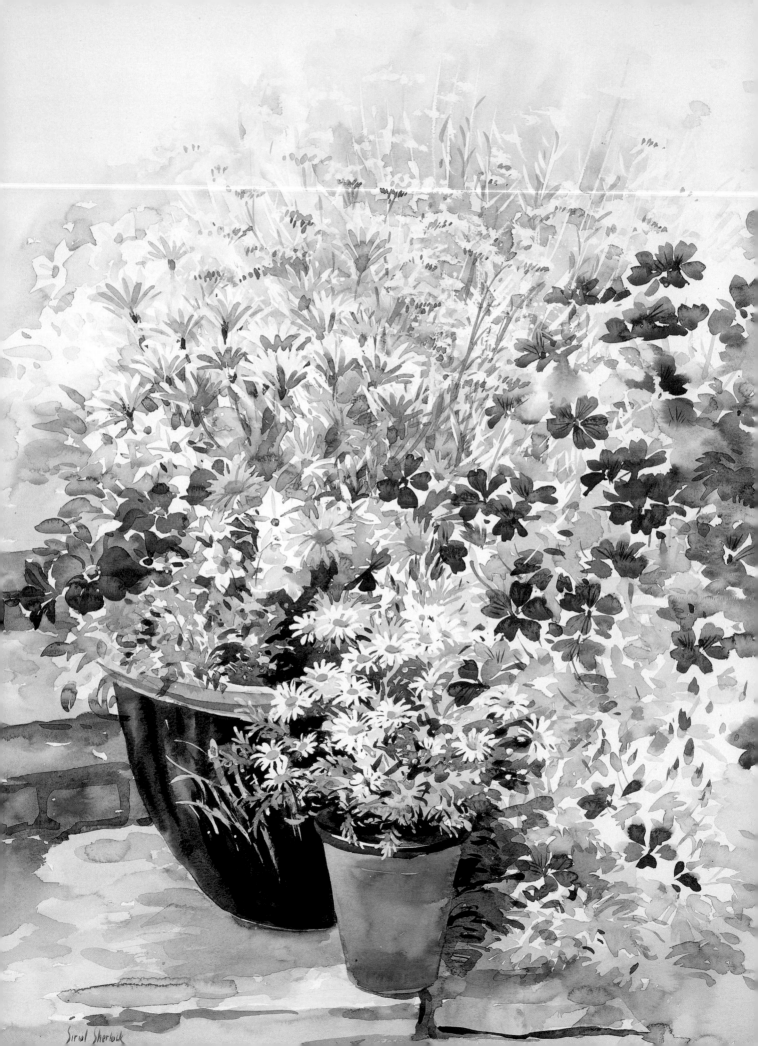

Siriol Sherlock

The Blue Jug

In this painting I broke my rule of starting with the pale-coloured flowers first. The scarlet primulas were the focal point and needed to be put in first (yellow centres before the scarlet petals), so that everything else would fit in around them. Next I painted the yellow cowslips and the white narcissi (as usual, I pencilled in the outlines of the white flowers). The lilac was painted with a pale mauve wash and as this dried some of the little individual flowers were roughly picked out with darker colours, giving an impression of lilac without painting every tiny flower. The blue flowers were painted next, then the leaves and stems were added. The painting was finished by putting in the jug and the vague shadows.

The bright highlight contrasting with the strong blue of the china makes this jug look really shiny.

The granulation of the paint as it dried simulated the colour variations in the glaze beautifully. This happened purely by chance – French ultramarine is one of several colours which have a tendency to granulate and can produce lovely effects.

Method for the jug

1 The outline of the jug was lightly sketched in with pencil. Water was washed in all over the jug up to the pencil outline, leaving dry patches where the highlights would be.

2 A wash of French ultramarine mixed with Winsor violet was quickly washed in wet-on-wet, painting carefully around the white highlights. Darker blues were added wet-on-wet up to the edges of the jug and the lilac.

3 After the first layer had dried, dark blue reflections were painted wet-on-dry which helps to make the jug look shiny.

Tip

If you can't complete a large wash (like the surface of the jug) in one go, soften the edge of the painted area with a wet brush so that the paint doesn't dry with a hard edge.

Fig. 89

The Blue Jug
21 x 20 in (53 x 51 cm), 2 days,
mostly size 10 and 8 brushes

Siriol Sherlock

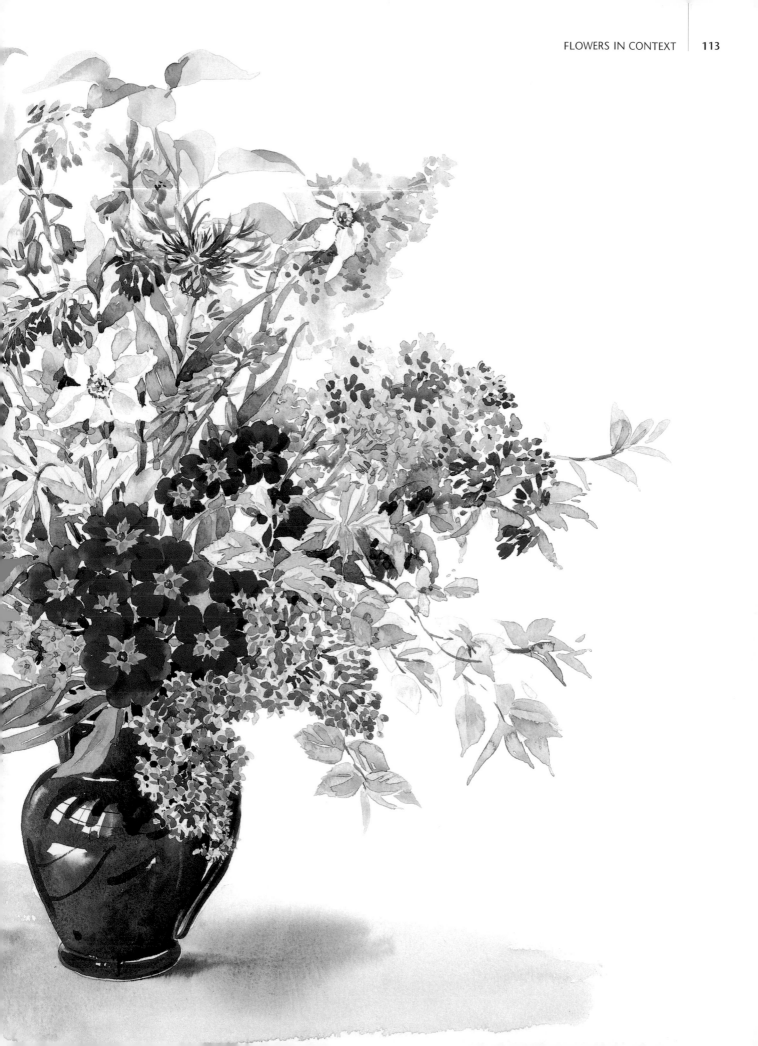

A still life

Setting up a still-life composition which looks natural and not too artificial can be tricky, but look at the compositions of fruit in *Three Apples*, page 99, *Conkers*, page 102 and the jug and pot in *Summer Roses*, page 67, for ideas.

Flowers in situ

Painting out of doors can be very frustrating when the conditions aren't perfect – it is usually too bright, too dull or too windy. With *White Dog Roses* I cheated by bringing the cut flowers indoors and sticking them into oasis so that they hung down, as they do in the wild. The vague leaf and flower shapes in the background give the impression that they are growing in a hedgerow. Who would know! *Intertwined*, which is shown on page 7, was painted 'in situ' in my garden.

Backgrounds

Backgrounds have to be added towards the end of a watercolour flower painting; if you put down a wash of background colour (even a very pale wash) at the beginning of the painting, this colour will dull any paint you lay over it. Think twice before adding a background – I have seen many a good flower painting ruined by a murky one. If you have spent many hours working on the flowers, don't risk ruining the whole painting by adding a background. If in doubt leave it out.

It is quite easy to add a few soft shadows or out-of-focus flowers and leaves which hint that there is something in the background (as in *White Dog Roses*, opposite and *Bluebells and Buttercups*, page 105). Painting a complete 'in focus' background as in *Lowland Tropical Forest Plants* on page 89 is quite difficult. It was essential to make sure all the foreground flowers and leaves were completed before painting in the leaves which appeared behind them.

The Last Roses

In *The Last Roses* (overleaf) after the flowers and vase were completed, the background was wetted around the flowers, a quarter of the painting at a time, and soft colours were dropped in around the edges of the petals which had previously been pencilled in. It was important to ensure that the colour in each area faded out into the wet paper and did not form hard edges.

I was not happy with my first attempt at a background, it needed something a little stronger to lift the white roses, so later on, I wet the background again and washed in deeper colours. As the first layer of paint was very pale, I got away with this – if the first layer had been stronger, I might have disturbed the colour and ended up with a very 'muddy' background. The strong blue-grey background in *Spring Posy* (shown on page 119) was more risky but the startling contrasts of colour and tone make it quite dramatic.

Fig. 90

White Dog Roses
14 x 10 in (35.5 x 25.5 cm), 1 day, brush sizes 8 and 5

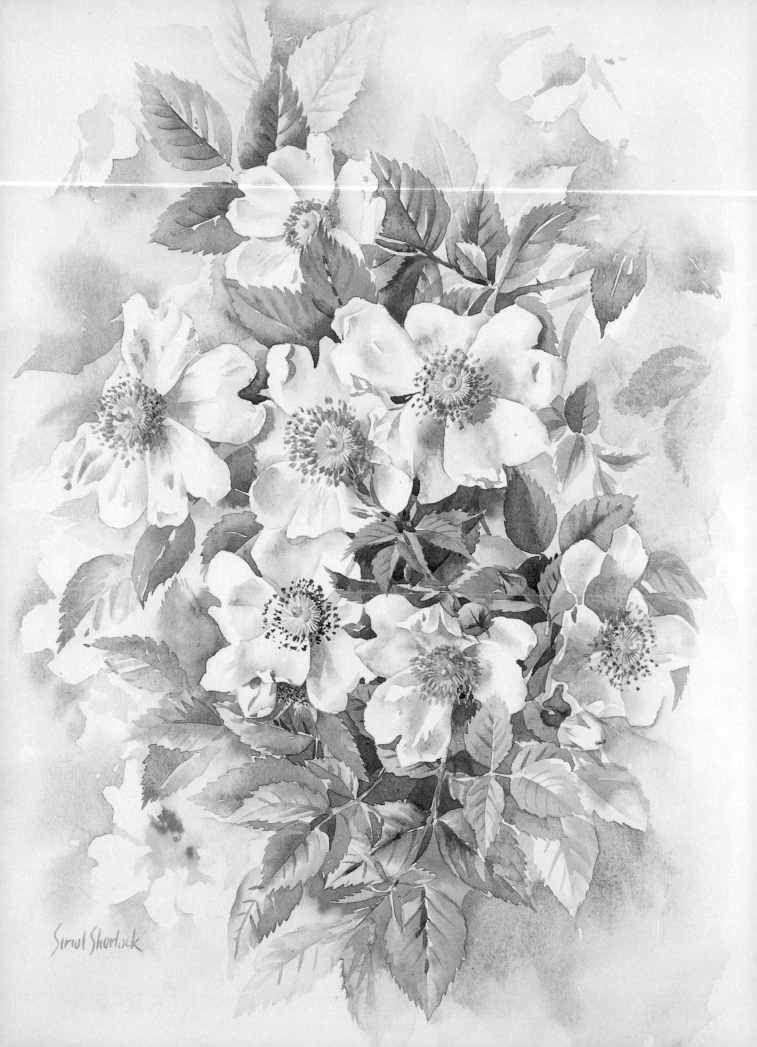

Siriol Sherlock

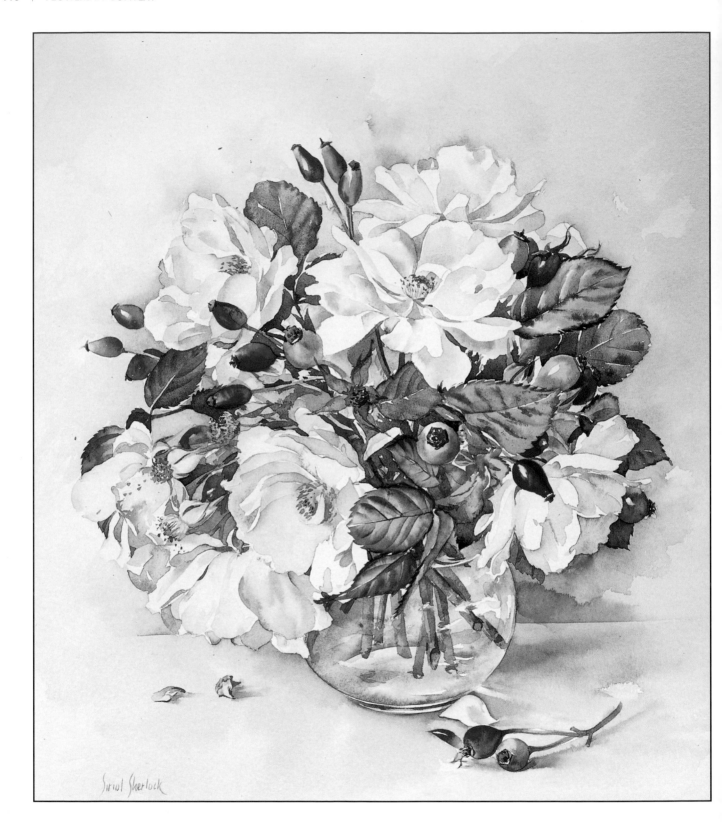

Fig. 91

The Last Roses
12 x 10 in (30.5 x 25.5 cm), 2 days,
brush sizes 8 and 5

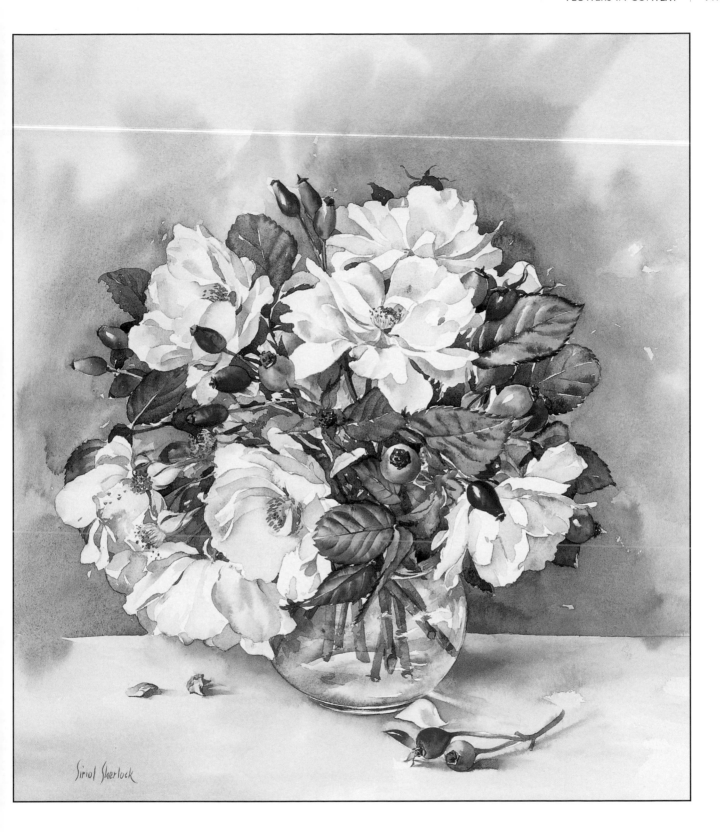

Fig. 92

The Last Roses (with strengthened background)

A dark background

The little flower arrangement in *Spring Posy* was transformed, by a washed-in dark background, into something quite dramatic, but remember, putting in a background can be a risky business.

Fig. 93

Spring Posy
14 x 10 in (35.5 x 25.5 cm), 2 days,
brush sizes 8 and 6

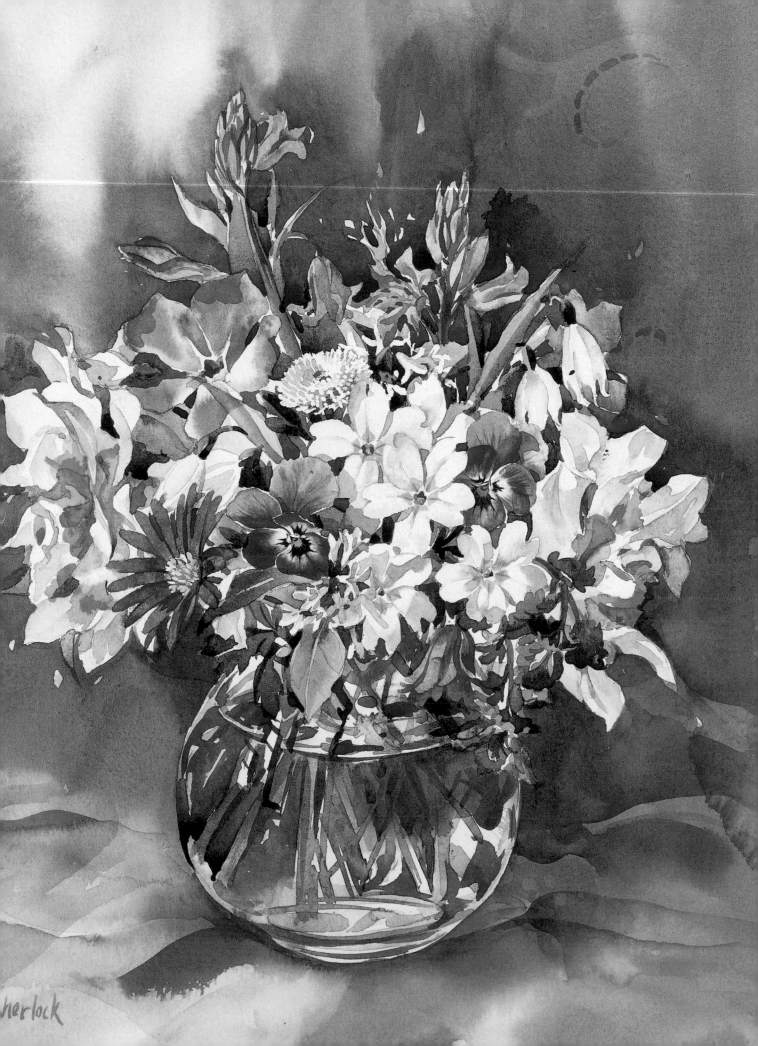

herlock

MAKING A LIVING

Most of us paint because we enjoy it. Making money out of it is a bonus and most artists will never make a living from their work. The sensible ones don't give up 'the day job' and keep painting as a hobby or a way to make a little extra money, but of course they have much less time to paint. Those of us who do take the plunge and work as an artist take a great risk. To make it work takes dedication, business sense, ambition and determination, plus of course talent and skill, and by choosing this option you risk spoiling some of the pleasure by adding commercial pressures and stress. You take a risk every time you place a picture before the public: will they like the subject, the style and the technique. Will it go with their colour scheme? – this is very important! Or is it too big for their home? Everyone wants to buy poppies, primroses or bluebells, but how many times do you want to paint them and how many different compositions can you come up with? The latter is not so important as every flower is different and if you paint from life, every painting will be different. When you paint an unusual plant you will also need a specialist buyer to appreciate it, as the average buyer is looking for familiar, pretty flowers.

Working as a botanical artist

I admire the dedication of the botanical artist who might spend years painting every variety of one species (dozens of different snowdrops for example) all with slight botanical differences. Whilst botanists might applaud the skill, dedication and scientific importance of such an undertaking will they reward the artist financially? Probably not.

At the 'botanical' end of the market there are few job opportunities for skilled artists. The Royal Botanic Gardens at Kew, for example, does employ a few, but most artists are self-employed and are commissioned to do paintings for botanists and botanical publications. Most have to rely on selling their paintings. Exhibiting your work at one of the Royal Horticultural Society's shows at Vincent Square in London is a great way to get noticed but there is enormous competition for space and they will only accept artists of a high standard. Botanical paintings are exhibited at four of the RHS Winter shows which can be a great source of inspiration where you can benefit from the tips of other artists.

Presenting and pricing your work

The way you present your paintings can have an influence on their saleability. For example, if you choose strong-coloured mounts or frames they may not go with a prospective buyer's colour scheme; and in any case they may 'kill' your painting. It is much safer to choose paler, more neutral colours.

Pricing your paintings is difficult. It is hard to be objective about your own work and many good artists undervalue their paintings. To return to the question in my introduction – how long did it take you? – I think the questioner looking at the painting in an exhibition, is often wondering if the painting they are looking at represents good value for money. They probably divide the cost of the painting by the number of hours it took to paint, in order to work out how much the artist is earning. Of course they invariably fail to deduct the gallery's commission, the cost of framing, possible hanging fees and various other overheads before they make that calculation! In fact the artist often takes home only 50 per cent of the sale price. These days everyone charges by the hour, or the minute in some professions, and they expect artists to do the same. But artists must be an exception, it isn't how long it took that gives a painting its value, it is the quality of that painting. Nevertheless, do take note of the hours you spend working on a painting and decide on a minimum rate (per hour) that you are prepared to accept after costs have been deducted.

Exhibiting flower paintings

If you want to put your work on show, there are a number of ways you can go about it. One way is to join a flower painters' society, such as the Society of Floral Painters, where there are opportunities to exhibit. If you are not able to become a full member, it is possible to become an associate so you can meet fellow artists and improve your skills. The Society of Botanical Artists was the first national society to be formed in Great Britain; the standard of work is very high and it can take years to be accepted as a member as numbers have to be limited. However, non-members are able to submit work for the huge annual exhibition in London; it goes before a judging panel who choose a selection of pictures to hang. Lay members are able to become involved in the society without being a full member. There is now an American Society of Botanical Artists and there are several regional societies such as The Leicester Society of Botanical Illustrators. There are, of course, hundreds of local art groups and societies who hold exhibitions of members work.

Holding an exhibition of your work, whether under the umbrella of a gallery, with a group of artists or on your own, is always a nerve-racking experience. The financial and personal commitment is high and it is always an enormous relief when that first red spot appears at a private view. Exhibiting at a gallery is probably the easiest option for the artist, as the gallery usually takes responsibility for hanging, private views, publicity and so on. However, there is a high price to be paid in gallery commission on sales – normally 33–45 per cent plus VAT, but it is worth paying the price if the gallery has a good reputation and lots of customers. Art groups and societies normally take 20–33 per cent and sometimes you pay a small submission fee for each picture and/or a hanging fee if the pictures are accepted and hung.

Organising your own exhibition is a great challenge and it is vital that you have both the right venue and good publicity. Restaurants, cafés and theatres are often interested in showing and selling paintings. Country shows and craft fairs can be good places to show your work, although high priced paintings are unlikely to sell, except at the most upmarket venues where stands are very expensive. Setting up and manning stands can be particularly exhausting, and marquees can be very damp, which could affect the paper even in framed paintings.

We all have bad times when nothing seems to sell and it is very easy to become disillusioned and lose confidence in your work, but don't give up. It isn't easy to get members of the public to part with their money unless you have something special to offer them – for example incredible detail, wonderful vigorous brush strokes, great colours or colourful decorative images. Find your own strengths and develop them.

The commercial world

Getting your work into print holds financial rewards but also many pitfalls. The easiest way to get published is through someone else, for example a company that sells greetings cards or fine art prints. They will normally give you a one-off payment for the right to reproduce your work – the copyright. It is up to you or your agent to specify if this is a limited copyright (for example for use on greetings cards only) or a complete copyright (which would give them the right to do whatever they like with your picture and is a very unwise choice). One image can be used for different purposes, for example as a card, a notelet or a diary cover and separate payments should be expected for each use. You should always put a time limit on your copyright agreement (from three to five years is normal) after which the copyright will revert to you. As the originating artist, you hold the copyright of your image until you agree to sell it, even though you may have sold the original painting. The only exception to this is where you have been specifically commissioned to paint a picture in a particular way for someone (as with a portrait for example); this is rather a grey area in law.

Sometimes a company may wish to pay you royalties (a percentage of sales), which saves them from paying anything up front; check that it is a sound company with a proven market or you may never see those payments. Occasionally artists with a proven commercial value are offered a combination of a copyright payment and royalties.

You can publish your own work, but be sure you have a commercial product (your favourites are not necessarily commercially viable!) and a market-place before you do so. From my own experience I would suggest that you clarify in your own mind whether you wish to work purely as an artist, or get involved in business at the cost of losing some of your painting time. A good agent will show your work to suitable clients and leave you free for painting, but of course you have to pay the price in commission.

If you have a good eye for design, flower paintings can be used as reference material for items such as fabrics, stationery, wrapping paper and packaging. I started out painting flowers for my textile designs and eventually the flower painting took over!

Whether you try to 'sell yourself' or do it through an agent, keep a good stock of quality photographs of your best paintings ready to send off. Photographing paintings, especially those with white backgrounds, is very difficult. Get advice from an expert or pay a professional to do it for you. If you are sure your work has potential in print, get a good specialist photographer to produce large transparencies which can be kept after the painting is sold; printers can usually work from these instead of the originals. They are expensive but could be a good investment for the future. Unfortunately, however, printers can never quite do justice to the original – the colours are never quite as bright or true and inevitably some of the quality of watercolour painting will always be lost.

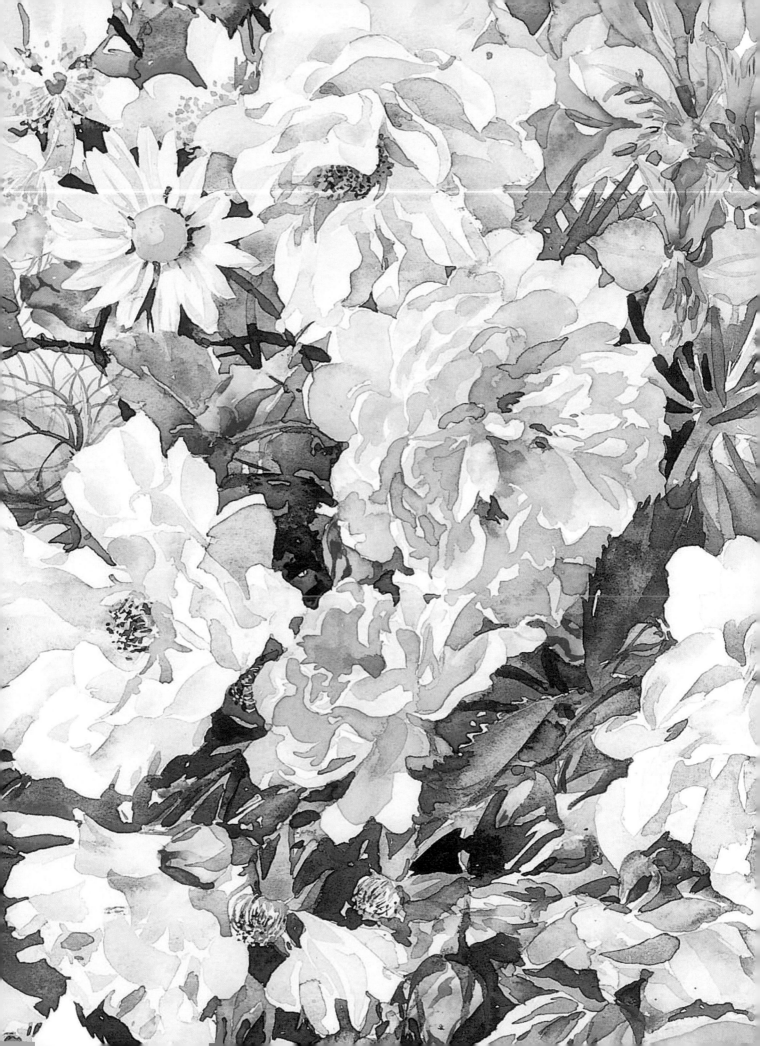

CONCLUSION

Floral or botanical art received great recognition at certain periods of the seventeenth, eighteenth and nineteenth centuries. Sadly in the twentieth century it became the poor relation, overwhelmed by the impact of abstract and innovative art forms. Happily flower painting is now enjoying a huge revival across the world. Artists receive enormous praise and support from the public who appreciate the great skills and talent involved. Art critics who have taken little or no interest in the past are beginning to pay some attention. Whether you hope to make a huge impression as an artist or just want to paint for your own pleasure, there has never been a better time to get painting!

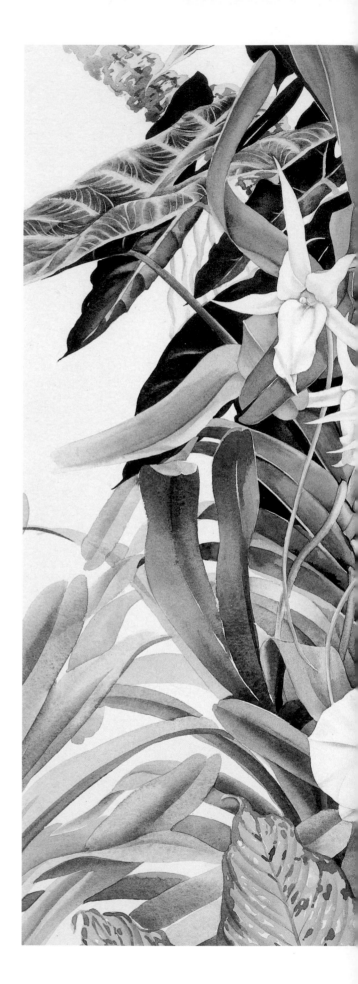

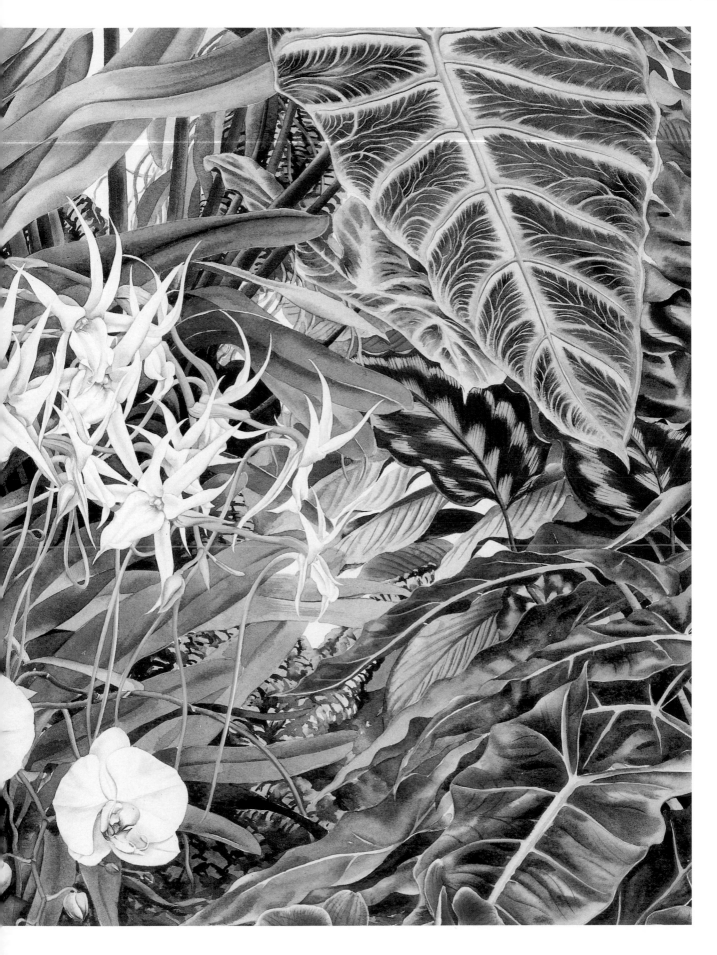

BIBLIOGRAPHY

Michael Hickey and Clive King, *Common Families of Flowering Plants*, Cambridge University Press
A useful book about basic botany and plant structures.

The Encyclopedia of Garden Plants and Flowers, Reader's Digest Association Ltd.
This has a useful preface on the naming of plants, and information at the back of the book on the structure of plants, flower and leaf shapes and so on.

The Gardeners' Encyclopedia of Plants and Flowers, The Royal Horticultural Society
This definitive reference book contains all the Latin names of plants and includes a useful index of common names for cross-reference.

Michael Hickey, *Plant Names: a Guide for Botanical Artists*, Cedar Publications
This useful booklet clearly explains the naming of plants.
Available from Michael Hickey, Hamlyn Cottage, France Lynch, Stroud, Gloucester GL6 8LT (send a cheque for £2.50, including postage and packing).

The Species Conservation Handbook, English Nature
This contains a definitive list of protected flora and fauna, including codes of conduct.

Contemporary Botanical Artists: The Shirley Sherwood Collection, Weidenfeld and Nicholson.
This contains many and varied paintings by living artists and is a great source of inspiration.

Journals

Curtis's Botanical Magazine (Incorporating the *Kew Magazine*), published quarterly by Blackwell Publishers for the Royal Botanic Gardens, Kew.
Includes beautiful illustrations by contemporary botanical artists.

The New Plantsman, published quarterly by The Royal Horticultural Society.
Includes illustrations by botanical artists.

USEFUL ADDRESSES

The Botanical Society of the British Isles (BSBI)
Contact them c/o The Natural History Museum, South Kensington, London
This society is due to publish an updated leaflet on the Code of Conduct for the conservation of wild plants.

English Nature Enquiry Service
Northminster House, Peterborough PE1 1UA
Contact them for details about availability of *The Species Conservation Handbook*, or send a stamped addressed envelope requesting the list of protected plants from the handbook.

The Royal Horticultural Society
Shows Department, 80 Vincent Square, London SW1P 2PE
See page 119 for information on visiting, or exhibiting at, their plant and botanical art shows.

The Society of Botanical Artists
Executive Secretary: Pamela Henderson, 1 Knapp Cottages, Wyke, Gillingham, Dorset SP8 4NQ
Send a large stamped addressed envelope in November to enter the open exhibition in the following year.

The Society of Floral Painters
Chairman: Anne Middleton, 89 College Road, Woolston, Southampton SO19 9GD
Send a large stamped addressed envelope to receive details.

Two Rivers Paper Company
Pitt Mill, Roadwater, Watchet, Somerset TA23 OQS
This paper is available from many art shops or by mail order direct from the company.

INDEX